IMAGES
of A m e r i c a

LEE COUNTY
ISLANDS

Lee County's barrier islands are shown on this map. From north to south, they are as follows: Gasparilla Island, Cayo Costa, North Captiva Island, Captiva Island, Sanibel Island, and Estero Island. Located in Pine Island Sound are Useppa Island and Pine Island. The smaller islands featured in this book are scattered within Pine Island Sound and San Carlos Bay, with one in the Caloosahatchee River at Fort Myers. (Map by Merald Clark, from *Fisherfolk of Charlotte Harbor, Florida*, by R. F. Edic. Reprinted with permission, Boca Grande Historical Society.)

ON THE COVER: Larry Stults and his wife, Jan, are responsible for opening Cabbage Key as an isolated, intimate resort. Purchased in 1944, the island resort, accessible only by water, was run by the Stults family until 1969. In this photograph, Larry Stults enjoys his tropical island paradise on Cabbage Key in the 1960s. (Wells family collection.)

IMAGES
of America

LEE COUNTY
ISLANDS

Mary Kaye Stevens

ARCADIA
PUBLISHING

Published by Arcadia Publishing
Charleston, South Carolina

Printed in the United States of America

Library of Congress Control Number: 2009927174

For all general information contact Arcadia Publishing at:
Telephone 843-853-2070
Fax 843-853-0044
E-mail sales@arcadiapublishing.com
For customer service and orders:
Toll-Free 1-888-313-2665

Visit us on the Internet at www.arcadiapublishing.com

*To my parents, Rev. Albert O. and Ruth Loeber, who taught
me to cherish my family's history, while creating my own*

CONTENTS

ACKNOWLEDGMENTS

Without the assistance of many individuals and organizations, the production of this book would not have been possible. I am grateful to the following individuals for their time, courtesy, and help: Virginia Morton, Kenneth Wells, Phyllis Wells, John and Lil Honc, Bob and Karen Long, Dick Darna, Kay Cousins, Dale Jedlick, John and Virginia Knight, Charles Bell, Dennis Labbe, Helen Smith, Rona Stage, Mary Cusker, Al Howard, Judy Wiggins, Jack Howard, Mary Baker, Scott and Peggy Harris, Alvin Lederer, Robert Edic, A. J. Bassett, Robert Macomber, Harvey Hamilton, Pete Bowen, Barb Darling, Alex Werner, and Robert and Barbara Shafer. Also, my gratitude goes to the late Kay DellaBitta and Elaine Jordan, who did not survive to see the finished work. My gratitude extends to my editor, Lindsay Harris, who has guided me through this rewarding project.

A special thank you to my family for their ceaseless encouragement: Karisa, Scott, Ali, and Clayton Workman; Craig, Staci, Skyla, and Cay Stevens; Ruth Loeber; and Maurice and Doris Stevens. My husband, Dan, deserves the ultimate thanks for once again giving tireless support for me and my dreams.

The memories of the dozens of individuals interviewed for this book provide the captions for many of the images. I can promise that the conversations and events are recorded as truthfully as I could relay them. When possible, I researched the facts as interviewees recalled them. Please understand that despite my efforts toward accuracy, if some factual errors or faulty remembrances are found within these pages, they are not intentional.

Thanks to the following sources for photograph and artwork usage throughout this book: State Archives of Florida (SAF), The Sanibel Historical Museum and Village (SHMV), the Southwest Florida Library Network (SWFLN), Florida Heritage Collection (FHC), Fort Myers Historical Museum (FMHM), Southwest Florida Historical Society (SWFHS), Lee County Historical Society (LCHS), Boca Grande Historical Society (BGHS), Museum of the Islands (MOTI), Pine Island Public Library (PIPL), Useppa Island Historical Society (UIHS), Sanibel Public Library (SPL), and the Estero Island Historical Society (EIHS).

INTRODUCTION

Imagine straw hats, vibrant hibiscus and palm trees,
the intense color and sound of the Gulf of Mexico. This fantasy is reality.

—India Hicks, *Island Life*

Some of the most pristine tropical islands in North America lie scattered along the Lee County, Florida, coastline. The islands have each developed their own unique personality while sharing in some basic historical similarities. Relatively isolated from mainland society until the mid-1900s, the islands were inhabited by the fierce Calusa Indians as early as 500 BC. Later, in 1513, Juan Ponce de León was to be the first documented Spanish explorer to visit the islands. On Ponce de León's final voyage, the crew fought a fierce battle with the Calusa Indians on Pine Island. Suffering extensive battle injuries, Ponce de León and his men returned to Cuba, where he died of his wounds.

By the late 1700s, Lee County's islands were home to legendary pirates, including Brewster Baker, José Gaspar (Gasparilla), Black Caesar, and Juan Gomez. Although never substantiated, it is still believed by islanders that treasure remains hidden on most of the islands, keeping the anticipation of discovery alive.

Lee County's islands remained basically untouched by civilization for about 20 years after Florida was granted statehood in 1845. Fishermen, setting up camps, were the first communities to dot the islands in the mid-1800s. These fishermen of pre–power engine days plied the waters in lighterns (rustic, flat-bottomed houseboats), skiffs, and wooden pole boats. The Homestead Act of 1862 brought an influx of hardscrabble pioneers to the islands. Beginning in 1885, when the first tarpon was caught at the mouth of the Caloosahatchee River, a new breed of fisherman—the sports fisherman—arrived. Classy hotels and elegant resorts offering adventure appeared on each of Lee County's main islands. Celebrities, including Thomas Edison, Henry Ford, Shirley Temple, Theodore Roosevelt, Hedy Lamar, and Edna St. Vincent Millay, fished or wintered on the islands.

The isolated lifestyles of the previous dwellers are what set the stage for today's residents. Lee County's islanders pride themselves in being just a bit more eccentric than mainlanders. Today's residents and visitors, as those before, live on island time. They live by their own inner clocks, not following any standard set by the mainland world. It is this lackadaisical pace that tourists find intriguing and charming. So it is with a determined fervor that Lee County's islanders fight to preserve their piece of paradise, as the future of the islands rests in the caring, nurturing hands of island residents determined to preserve both the beauty and tranquil lifestyle they cherish.

One

GASPARILLA ISLAND

If there is better tarpon fishing in the world than can be had at Boca Grande, I have never heard of it.

—A. W. Dimock, *The Book of Tarpon*

Split between Charlotte County and Lee County, Gasparilla Island is home to Lee County's most northern island address. Boca Grande lies on the southern end of Gasparilla Island, a stone's throw from Cayo Costa Island. Until the late 19th century, the island remained sparsely settled by a handful of fishing families. In 1848, the federal government established a military reservation at Boca Grande, overseeing the northern end of Cayo Costa Island and the southern end of Gasparilla Island.

It was not until 1897 that Boca Grande became the legal name, when Albert W. Gilchrist purchased land and filed a plat for "The Town of Boca Grande" in the Lee County Courthouse in Fort Myers. Earlier the Spanish settlers had referred to the location as *Boca Grande*, or "Big Mouth," to identify the exceptionally wide passage to Charlotte Harbor.

Beginning in 1905, construction began on a port facility and railroad spur to receive and ship phosphate ore mined in the Peace River Valley. With the development of the Charlotte Harbor and Northern Railway (CH&N) came access to the outside world. In addition to the fish camps or ranchos of the area, fish houses were established along the rail line, which brought in ice from the mainland (Punta Gorda) and shipped out fresh fish. In 1911, the Gasparilla Inn opened. The hotel was such a success that by 1914 a casino was built near the inn and a boathouse was added on the bayou.

Game fishing and tourism are responsible for most of the development during the 1920s. By 1925, more and more eastern Florida residents were becoming disenchanted with the Florida boom and opted to give up their east coast homes for the remoteness of Southwest Florida's islands. With the attraction of unparalleled tarpon fishing along with the relatively unspoiled island setting, Boca Grande became a very desirable location.

As with other island communities, development tapered off after the Florida land boom. Yet, because of the tropical weather, the sandy beaches, and some of the world's best game fishing, Boca Grande continues to grow. Fortunately, due to the sensitivity of the island's residents, much of the early bungalow-style architectural heritage still remains today, preserving the quaint ambience of the past.

The first official surveys of Lee County's islands and the Everglades were conducted by a team hired by the surveyor general of Florida led by Horatio Jenkins and Marcellus Williams beginning in 1874. Although they charged $12 per mile (the going rate for the time was $4 or $5), it was determined that "the notations on the documents [were] indicated 'by calculation;' in other words, not surveyed on the ground but by mathematical means," according to Joe Knetsch in *Boca Grande*. The surveys were determined to be fraudulent. Albert W. Gilchrist was responsible for correcting the Jenkins surveys in 1897. His bill to the government was $566.83. These surveyors conducted a later survey in 1915. (SHMV.)

The journal of Harry "Pete" Goulding, who fished with his father, Joseph, in the early 1900s, is recorded in Williams and Cleveland's book on Charlotte Harbor, *Our Fascinating Past, Charlotte Harbour: The Early Years*. Pete, describing the run boats, wrote, "They could carry thousands of pounds of ice or fish. They left Punta Gorda at 7 a.m. on Monday, Wednesday, and Friday; stayed overnight the farthest ice station; and returned to Punta Gorda by 1 p.m. on Tuesday, Thursday, and Saturday. The men came home Saturday afternoon and drew their earnings at the fish house for which they worked. Then they and their families went shopping." The *Carroll*, pictured here, was one such run boat. (BGHS.)

Beginning in 1911, the pilot boat *Comet* served the Boca Grande docks. At 40 feet long and 8 feet wide, it was made of cypress. A short time after the Boca Grande Pilots Association formed in 1888, Capt. Peter Nelson became a pilot. Since 1906, when Captain Nelson retired, all of the Boca Grande pilots up to the present day have been named Johnson, either from the Capt. I. W. Johnson or Capt W. H. Johnson family. More than nepotism, it was simply easy and convenient for a father to take his son with him on the pilot boat and, later, onto the ships. When the son was old enough, he would become indentured to his father or another pilot and become an apprentice. (BGHS.)

By the late 1920s, the *Catherine* ferry was joined by the *Saugerties*, a 65-foot diesel-powered ferry carrying up to 11 cars for the 45-minute trip between Placida and Boca Grande. Capt. Carey Johnson reflected on his time as relief captain on the ferry: "It was a good way to meet and get to know some very important and interesting people." The *Saugerties* remained in operation until the causeway was completed in 1958. (SAF.)

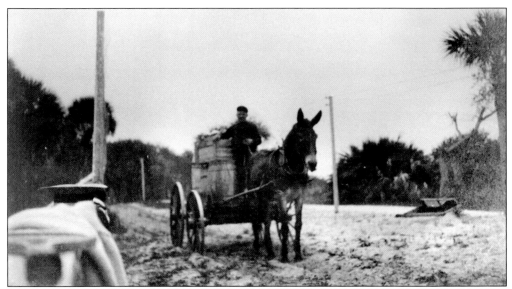

In 1915, any Boca Grande route used by horses was soon decorated by horse droppings, which were considered unsightly, had a foul odor, and were unhealthy for the residents. Likewise, outhouses needed to be emptied on a regular basis. The Honey Wagon, a horse- or mule-drawn wagon hauling barrels to be filled with horse droppings or outhouse contents by the driver and a helper, was an important conveyance. The wagon did not have to be on duty very long before its presence could be detected from several blocks away. During the summer months, residents would make an effort to avoid the Honey Wagon route. (BGHS.)

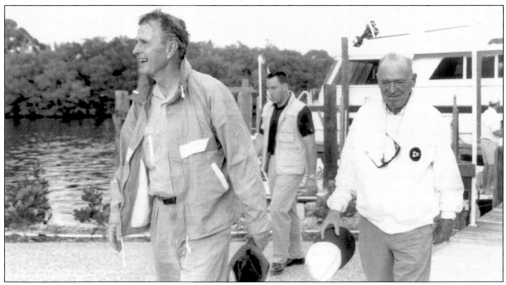

At first, Bayard Sharp's life in Boca Grande was purely recreational. Before moving to the island, he came for hunting and fishing. But he quickly became an integral part of island life, especially after 1963, when he purchased the Gasparilla Inn and Cottages. Shown here with longtime friend and frequent houseguest former Pres. George H. W. Bush, Sharp often reminisced about Boca Grande's breeze: "The breeze that sweeps across the island is a soft, damp-laden breeze, bringing with it the scent of sea and flowers. I term it the 'island breeze,' and I am always surprised by its stirring gentleness." (BGHS.)

Loaded with engineers, laborers, tents, instruments, food, and other supplies, the steamer *Mistletoe* landed on the south end of Gasparilla Island on November 28, 1905. With the tent encampment set up near the Boca Grande Lighthouse, the crew began work on the CH&N. A little more than two years later (in 1908), the trains began the Arcadia-to-South Boca Grande run. Later, in 1911, the phosphate loading facility began operations, servicing ships from northern U.S. cities and foreign countries. For more than 50 years, Boca Grande, one of the deepest natural ports on the coast of Florida, was the shipping point of Florida's phosphate. (Both, BGHS.)

Teacher John Fish poses with his students at the Gasparilla School in 1924. Some of the children pictured are Albert Lowe, Gussie Cole, Bert Cole, Margaret Cole, Raymond Lowe, Oveda Rye, Audrey Rye, Van Bass, Genevieve Downing, Austin Bass, Ansell Underwood, Everton Underwood, and Elsie Sands. Of the graduation ceremonies in 1912, the *News-Press* wrote, "The Boca Grande High School exercises were on April 11. Professor Thomas got up quite a program . . . a three-act play 'Just Like Percy.' The room was handsomely decorated, and it was packed with people. Superintendent Sumner visited the school for the graduation exercises. It was the largest crowd ever assembled in Boca Grande." (BGHS.)

In 1911, the Boca Grande Land Company paid $215 to Hires and Folsom Construction Company of Wauchula to build the Boca Grande Schoolhouse. The first teacher was Hilda Ausland, and the first principal was E. B. Williams. A second story was added to the building in 1914, qualifying the school as a junior high. The school closed in 1929, when a new Boca Grande School was built. One of the old buildings was removed and replaced by duplex housing for teachers. (BGHS.)

In the 1920s, the Boca Grande School Boat provided transportation for students living on the outer islands. Although the subjects in this image are unidentified, some of the children who attended the Boca Grande School, well known by today's Boca Grande residents, are Dellmar Fugate, Richard Coleman, Perry Padilla, Nell (Padilla) Kuhl, Helen (Sprott) Bower, Capt. Carey Johnson, and Charlie Bell. (BGHS.)

With a family of 14 children in need of an education, James Coleman was responsible for hiring the first black teacher and opening the first black school on Boca Grande in 1915. His granddaughter, Florence Jelks, reminisced in *Boca Grande: Lives of an Island*, written by the Boca Grande Historical Society: "To have been born on Boca Grande was a privilege. It's wonderful when we think of it—how fortunate we were to be there. It was blacks on one side, whites on the other side, of course, we were 'quartered' then. It was called the 'Quarters.' We didn't notice it back then." Pictured here, Florence Jelks speaks at a Boca Grande Historical Society History Byte on March 2, 2005. (BGHS.)

Pertaining to an incident where younger sister Jeannette got into trouble with their mother, Florence Jelks recalled in *Boca Grande*, "My mother gave her a good hiding. In the olden days folks didn't do so much talking and did a whole lot of whuppin'. And that's why we are where we are today—because the whuppin' stopped and too much talking is going on. Other than that it would be a better world." Jeannette cradles a bunch of Oleander blossoms in this 1940s photograph. (BGHS.)

The Boca Grande High School class of 1955 enjoys a graduation banquet at the Temptation Bar and Grill owned by Homer J. Addison. Pictured from left to right are the following: Dick Darna, Robert Sullivan, Skipper Harrison, Artis Bell, Ruby Coleman, Cappy Joiner, Babe Darna, Lewis Dolan, and an unidentified female graduate. (Charles Bell.)

As the island's oldest remaining original building, the Boca Grande Lighthouse (originally named the Gasparilla Island Light Station) was constructed in 1890. Capt. William Lester was the first lighthouse keeper to live in the one-story frame dwelling raised on iron screw-piles. It was his responsibility to keep the kerosene lamp inside the lens lit and to keep the Fresnel magnifying lens revolving through the night. (FMHM.)

A second Gasparilla Island Light was constructed in 1881 to serve as the Delaware Breakwater Rear Range Light. The light was discontinued in 1918, and the tower was disassembled in 1921, eventually reassembled on Gasparilla Island in 1927. In 1932, it was lit to serve as the rear entrance range light for Port Boca Grande. The Boca Grande Rear Range Light remains in operation at its new home today, guiding vessels safely through the Boca Grande Channel into the safe confines of Charlotte Harbor. (Author's collection.)

In 1907, Hughes' Floating Hotel, anchored near Boca Grande Pass, advertised "close to the action accommodations" for tarpon anglers. Describing the scene at such hotels, A. W. Dimock wrote, "I have seen a yachtsman quietly enjoy his magazine and cigar on the deck while his guide trolled for tarpon within a few hundred feet. When a tarpon was hooked, the sportsman laid aside his magazine and was rowed out to the skiff of his guide, from which he captured what was left of the fish." (BGHS.)

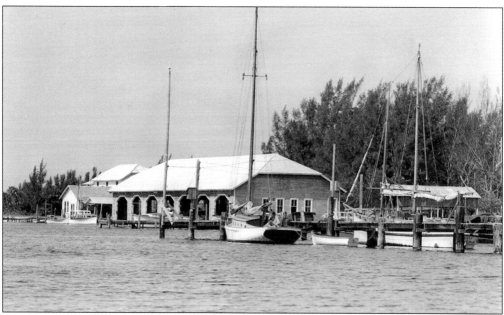

Founded by Sam Whidden in 1926, Whidden Marina has been run by the Whidden family ever since. In addition to being one of the oldest marinas, Whidden's was also a well known Boca Grande nightspot, dance hall, and restaurant in the 1930s. This image was taken before 1947. Although no longer a dance hall, the flavor of old Florida remains strong into the 21st century. (SAF.)

Walter Gault, pictured here in an undated photograph, purchased the Gasparilla Fishery built by the Punta Gorda Fish Company in the early 1900s. When the gulf shrimping industry came to the Southwest Florida coast around 1949, Gault expanded his operation by building a fleet of shrimp boats, pictured here in the early 1980s. Beginning in 1939, Tom Parkinson managed the fish house for Gault, while he also worked as a fishing guide. Parkinson enjoyed sharing memories of his guiding days, when he made $15 a day. In a *Boca Beacon* interview in 1987, Parkinson said, "The stories they told were worth the price of the charter. Going price these days is $400, and the stories aren't near so good." (Both, BGHS.)

This posh, state-of-the-art electric-powered streetcar could carry up to 30 passengers between downtown Boca Grande and Port Boca Grande. Owned and operated by the Charlotte Harbor and Northern Railroad, the streetcar provided service from 1910 to 1920. (BGHS.)

Swimming in the Gulf of Mexico required a full set of clothing in the early days of the 20th century. Note the girls' hats, sleeves covering their shoulders, and skirts or leggings to cover their legs, while the boys have on sleeveless shirts and pants above the knee. Paul Preston Speer (second from left) joins his friends for a day on Boca Grande's beach around 1913. (SHMV.)

Charlotte Harbor lies in the background of this 1972 aerial photograph taken shortly after the lighthouse renovation and Florida Power and Light Company's (FPL) shoreline refurbishing. Within seven years of this image, the last ship would sail from the port. Ironically, the last ship left the Boca Grande docks in 1979, while the last train left Boca Grande's depot exactly 100 years earlier in 1879. (SHMV.)

Known to residents as simply "Murdock," this bicyclist peddled peanuts all over Boca Grande in the 1940s. At 10¢ a bag, everyone looked forward to his arrival. Charles Bell told of a time when Murdock said, "I have some nice hot peanuts here, Mr. Bell." Charles's father replied, "But I don't like them hot." Always a salesman, Murdock insisted, "Oh, these aren't *too* hot!" (BGHS.)

Angelo C. Bell sizes up his catch of jewfish (goliath grouper) in this 1953 image. The fish were plentiful and were sold to Tom Parkinson at the Boca Grande Fishery. After the fish were beheaded and gutted, they brought 8¢ per pound. He did not catch the fish with the rod; a tourist asked him to pose with the rod as a joke. (BGHS.)

Boca Grande's electricity depended upon the old powerhouse built in 1910, which remained at the port for 42 years. In this 1920s image, the huge 110-foot-tall smokestack is visible beside the steam plant that was fired by bunker-C oil. Switching from the old powerhouse to FPL lines took place in 1952, after Wiley Crews spearheaded the project to bring power to the island. (SHMV.)

As one of the largest surviving resort hotels in Florida, the Gasparilla Inn was constructed by the Boca Grande Land Company for wealthy northerners. Initially known as the Hotel Boca Grande, references state it officially opened for the 1911–1912 season. The inn hosted tycoons such as J. P. Morgan, Henry DuPont, and Florida railroad and resort magnate Henry Plant. In 1928, Barron Collier purchased the inn for $150,000. By 1964, Bayard Sharp had become sole owner. The center of village life on Gasparilla Island since 1913, the inn has remained a premier destination on Florida's Gulf Coast. This image of the Gasparilla Inn dates to the 1940s. (SHMV.)

With four wings radiating from a central atrium, the Boca Grande Hotel was a large, three-story building welcoming many celebrities of the period. Built by Joseph Spadero in 1929, the hotel was located south of First Street facing Gulf Boulevard. Not only did the hotel offer a wide stretch of pristine beach, it also boasted a golf course, riding stable, tennis courts, and private landing strip. (BGHS.)

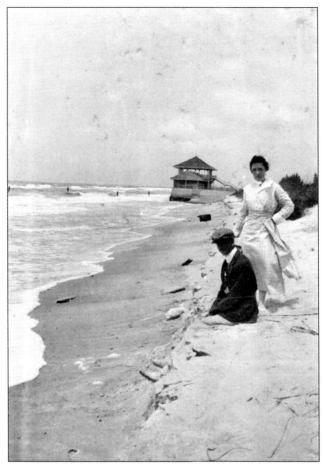

In an article printed in the *New York Times* on December 23, 1917, professional golfer Harry Cowie was considered "a follower of the royal and ancient sport of golf, who are not content to sit idly by throughout the winter of the Northern section of this country and who have to have at least one or two games of their favorite sport." Among the first golfers to make the migration south, Cowie wintered at the Gulf Shore Golf Links. Above, Cowie is with wife Florence on the beach at Boca Grande in 1918. The landmark Beach Bathhouse is in the background. Below, as the Gasparilla Inn's golf pro, Cowie is shown with the links' black caddies in 1923. Cornelius Minor, known as "Tiger," is the one-armed caddie in the white shirt (right of center). (Both, BGHS.)

Taken on Boca Grande's beach, an unidentified man is torn between two women in this photograph taken on May 7, 1926. The Australian pines in the background were once common on the island. The non-native species has a shallow root structure, easily uprooted by storms. Not surprisingly, many of the trees were uprooted during Hurricane Charley in August 2004. (SAF.)

This 1950s postcard shows an aerial view of Boca Grande, Boca Grande Village, the Gasparilla Hotel, and the railroad depot. Looking north, the Gasparilla Inn is in the upper right, and the depot is in the center. Port Boca Grande loaded between 200 and 300 ships from all over the world during its peak years of the 1960s and early 1970s. When phosphate could be handled more efficiently out of Tampa and Manatee County, the port began to dwindle, and in 1979, a Japanese ship laden with phosphate was the last ship to leave the port. (BGHS.)

Two

CAYO COSTA ISLAND

We spent carefree days, gathering shells, swimming, sailing boats and doing things that children do.

—Dolores Willis

The Drew's New Map of the state of Florida from 1874 captioned Cayo Costa Island as "La Costa Island." Many former residents still refer to the 7-mile-long-by-200-yards-wide island as La Costa, refusing to use the contemporary name, Cayo Costa. It is said the island's name, meaning "island of the coast," originated with the legendary pirate José Gaspar, famed leader of pirates in the 1700s.

Toribio and Juanita Padilla were the first known settlers on Cayo Costa. At age 19, Padilla recognized the island as an ideal spot for a fish ranch, so he returned to his home in the Canary Islands and relocated his family. The ranch expanded as each family member built a palm-thatched home. The fishermen prospered by salting their daily catch and selling it, upon which it would be shipped primarily to Cuba. The last Padilla family members left Cayo Costa in the late 1960s.

When the U.S. Navy built a quarantine station on Cayo Costa at the beginning of the 20th century, a new group of homesteaders arrived. Ships coming into port stopped at La Costa, where a physician checked the men for communicable diseases and quarantined those who were infected. It is said a brothel also existed on the northern tip of the island that which was frequented by navy personnel stationed at Port Boca Grande.

Today Cayo Costa is part of the Florida state park system, but it still has signs of past settlers. Most of the island remains uninhabited, allowing visitors to enjoy sugar sand beaches, fishing, and camping in complete solitude.

According to author and anthropologist Robert Edic in *The Fisherfolk of Charlotte Harbor*, "The most colorful figure was Toribio Padilla, a native of the Canary Islands, who founded a fishing ranch on Cayo Costa in the 1800s and later, allegedly, took up smuggling of aquardiente, or 'fire water.' The arrest and conviction of Padilla and his wife effectively removed the clan from the northern tip of Cayo Costa, but they later returned to the central area of the island." In 1910, Capt. Toribio "Pappy" Padilla passed away, and he is buried in an unmarked grave at their old homestead. This image is a watercolor by Mel Meo, a Pine Island artist. (Padilla family collection.)

In 1999, Frank Padilla, age 75, shared his family history: "My great granddad [the elder patriarch shown in this photograph] was a small child when he came with his parents from the Canary Islands. Their occupation was on the water with their boats. He built a house for himself and cabins for his skippers of three boats. The government came in and burned his houses and cabins to build the quarantine station." The extended Padilla family is also shown in this photograph on Cayo Costa in the 1880s. (Padilla family collection.)

Andrew Padilla, a Cayo Costa fisherman, is shown here in a pre-1900 photograph. The pole he is holding was used to move his boat from one location to another as he followed the schools of fish. Charles Bell was Padilla's grandson. (Padilla family collection.)

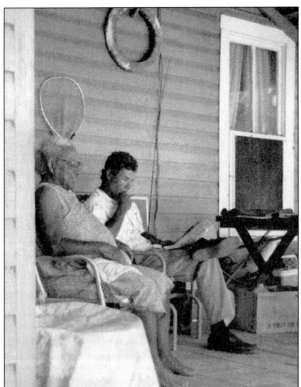

Robert Edic interviews Esperanza Woodring for his book, *The Fisherfolk of Charlotte Harbor*, in this late 1980s photograph. Born in 1902, Woodring recalled, "The fishermen fished from skiffs with bamboo poles and cast nets and took their catch to the little fish houses perched atop pilings in Pine Island Sound. They were paid 1.25¢ per mullet, regardless of size. When the fishing smacks anchored off Quarantine Rocks, old Toribio Padilla would visit the captains and return with yellow rice and black beans in exchange for the fish." (BGHS.)

Reflecting on the fishing techniques of her childhood on Cayo Costa, Esperanza Woodring told Robert Edic in a 1990 interview, "Do you know how they pulled the nets out of the boat? They had this great big thing, I think you would call it a wheel, I suppose. It was made out of palmetto stalks or wood." Once the nets were hauled out of the boat with the wheel, the nets were limed and then spread out on drying racks after each use; hence the term "net-spreads," as pictured in these early 1900s images taken in the Charlotte Harbor area. (BGHS.)

Recalling her childhood days on Cayo Costa, Dolores Padilla Willis, age 85, shared memories in a 1960s interview: "We didn't have sewing machines. Grandmother and aunts stitched all the clothing by hand. My first assigned duty, when I was five years old, was on Sundays when I would go to visit the fishermen who lived in the outer houses of the ranch. I was to thread needles for them so they could repair their clothing." These unidentified children were also raised on Cayo Costa. (Padilla family collection.)

The Coleman family moved to Cayo Costa in 1928. Nellie Coleman told Robert Edic in a 1990s interview, "It wasn't easy. We was raised on swamp cabbage, gopher turtles, and cornbread. Then they began to make laws that hurt the commercial fisherman. You couldn't catch this, and you couldn't catch that . . . they [the fishermen] didn't like anybody saying what to do. They wanted to be independent. That's how it was on Cayo Costa." This photograph shows Coleman with her dog Stinker in the 1940s. (BGHS.)

The Spearing House, shown here, was similar to the one Dick Darna grew up in before moving to the mainland with his family in the 1960s. His family is said to be the last original fishing family to leave Cayo Costa Island. He shared, "The worst thing about living on Cayo Costa was it was a hard life. We were taught you worked for what you had and did not expect anything to be given to you unless it was earned—including respect. We had a pure, simple life." (Padilla family collection.)

As in other parts of the country in 1925, celebrating Halloween involved far more tricks than treats. Cayo Costa revelers, including, from left to right, Jim Padilla, Perry Padilla, John Padilla, and Alfonso Darna, are dressed for celebrating. Jim is Perry's father, as indicated with a fatherly hand on the boy's head. (Padilla family collection.)

According to Lee County records, the Cayo Costa School opened in 1887, with Carrie de Costa as the first teacher. Other records list Capt Peter Nelson as the first teacher. No official school was established until 1911, when a building was erected by Alex C. and May Roesch. In the March 22, 1917, *News-Press*, teacher Miss Woodull said, "We have four or five pupils only, the older boys are caddying at the Useppa Golf Club to help their widowed mother." In a later *News-Press* edition, "The little school is surrounded with large oaks and cabbage palmetto trees, making it a lovely setting." (BGHS.)

At a 1990 reunion on Cayo Costa, Perry Padilla identified his fellow classmates in 1919: "That's my teacher Miss Woodhull. In front there's Eugenie Martin, Johnny Martin, Benny Pierce, Laura Woodring, Nell Padilla, and Joe Darna. In the back row, that's Phonso Darna, Henry Darna, Lola and Corinne Martin, and that little skinny guy—that's me, Perry." Henry Darna was given a gold medal that year for spelling. He missed only one word in 80 lessons. (BGHS.)

In this 1920s image, four Cayo Costa boys are beached in their wooden boat before pushing off for a day of fishing. The long poles were used for moving the boat through the water, as they had no motor or oars. Prevalent attire for the time were the wide-brimmed Spanish-style hats. Pictured are, from left to right, Alfonso Darna, Louis Padilla, Joe Padilla, and Perry Padilla. (Padilla family collection.)

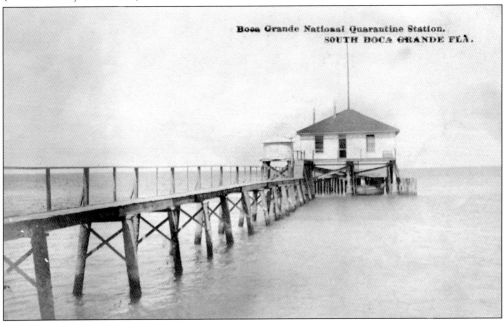

Although Cayo Costa Island's first post office was established in the quarantine station on the north end of the island, it carried the name "Boca Grande." Later the post office was moved to Gasparilla Island and the name of the post office located on Cayo Costa was changed to "South Boca Grande," as printed on this early 1900s postcard. (BGHS.)

Throughout Southwest Florida, Capt. Peter Nelson was a household name in the early 1900s. Besides serving as postmaster and teacher on Cayo Costa, he served as county commissioner for Monroe County (pre-Lee County days). He was also the founding father of the tiny town of Alva, located on the banks of the Caloosahatchee River. He chose the name "Alva" after he saw the small white flowers, similar to those in his native country of Denmark. His final days were spent on Cayo Costa, where he is buried in a nearly obscure cemetery. Here Nelson is shown in a c. 1900 photograph. His whelk shell–outlined grave is pictured in the late 1990s. (Both, SWFMH.)

Born and raised on Cayo Costa, Harvey Hamilton told of cutting Spanish bayonet plants, "We'd beat the long 'leaves' until the outer shell would break open. Then we used the fibers inside to pull and twist into thin line. That's what we used for fishing." He went on, "I remember the mosquitoes and sand flies being so bad I had to jump overboard to get away from them. We used 6-12 (insect repellent) so heavy it would burn the eyes out of your head." (MOTI.)

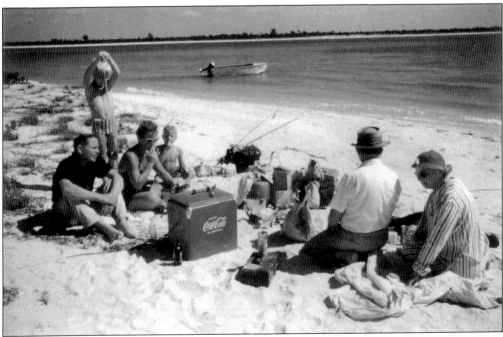

An unidentified family enjoys a Cayo Costa picnic in the 1960s. Along with fishing supplies, a Coca-Cola cooler is included in the picnic spread. Made by Action Manufacturing Company out of Arkansas City, Kansas, in the 1950s, the cooler featured a bottle opener mounted under the handle. (SAF.)

Three

CAPTIVA AND
UPPER CAPTIVA ISLANDS

The beaches are unspoiled, pristine . . . I like that.
There is nothing quite like the Gulf of Mexico—the color, the temperature,
the clarity of the water, make it one of the most beautiful beaches in the world.

—Willard Scott, *Sanibel and Captiva Islands*

The name Captiva comes from the Spanish word *cautiva*, which means female slave or captive. Legend has it that Gasparilla the pirate imprisoned his valuable female captives for safe keeping until their ransom money could be paid. Although there is no positive proof that the wives or daughters of wealthy families were detained on Captiva Island, the picture seems plausible and somewhat romantic to today's islanders, whether they are tourists or residents. Along with other Lee County islands, Captiva and Upper Captiva Islands remain relatively untouched by contemporary society and commercialism. Accessible only by a causeway joining Sanibel Island with the mainland, Captiva lies off Sanibel's northern tip, across a narrow bridge over Blind Pass.

First settled by pioneer homesteaders in the 1880s, the island has been home to a flourishing lime grove turned posh resort, an outdoor adventure school for boys, a fishing haunt of Theodore Roosevelt, and an eclectic restaurant. Accessed by steamer ships run by the Kinzie Brothers, visitors and residents of the early 1900s boarded the *Dixie* for their Caloosahatchee River and Pine Island Sound cruise, ultimately docking on Sanibel Island. Later a ferry service from Punta Rassa transported supplies and cars, as well as passengers, aboard the *Islander*. Planning ahead, drivers would race to get on the unpaved Sanibel-Captiva Road once off the ferry, as no one wanted to travel behind a car leaving billowing sand clouds in its wake. With the completion of the Sanibel Causeway in 1963, transportation was no longer dependent on a time schedule, allowing islanders the freedom of adapting a true island time mentality.

Pete Bowen of Fort Myers told of how he and some friends would ride along on the mail boat *Santiva* if space were available. Bowen recalled, "What the captain said, we did! No running, no playing, and no jumping. So we got bored. We started making little palmetto frond fans to sell to the tourists. "What are they for?" the tourists would ask. "Oh, you'll see." Bowen and his friends would drawl. When the boat reached Andy's Dock on Captiva, the tourists discovered the need for the fans—mosquitoes by the millions. (SHMV.)

Extensive damage caused by the 1926 hurricane forced most Captiva farmers to sell out to Clarence Chadwick, who planted the majority of the island in lime groves, evidence of which remains today. The original sand-and-shell road of the 1920s is barely visible through the Australian pines in this 1950 image. Erosion is evident in more recent photographs. (SHMV.)

At 11 feet wide and 8 feet above high tide, this wooden bridge connected Sanibel to Captiva at Blind Pass in the 1920s. Built in 1918, the final location and plans had to be approved by the War Department in Washington, D.C. The boat in the foreground belonged to Dean Mitchell. (SHMV.)

The Mail Boat

By 1936, the days of the steamers had come to an end, and the government contract for mail delivery was awarded to the Singleton brothers, Ray and Cleon, who operated a smaller gas-powered boat from Fort Myers to the islands. It was said one could set a clock by the Singleton mail boat, the *Santiva*. Punctuality was imperative: the U.S. Post Office fined mail contractors three days' pay for unsatisfactory service. In over 5,000 trips, the Singletons missed only two days due to hurricanes. This undated sketch is by G. Childs. (FHC.)

The purpose of the Snyder School for Boys was to live and study outdoors as much as possible. The school was originally set to occupy the old Schultz Hotel on Punta Rassa, but the hotel burned down before the school could occupy it. Catering to affluent families, the boys enjoyed winters on Captiva Island and summers in North Carolina. The upper image is of the Island Store, part of the original school complex. The lower image is a postcard of the Island Store designed by artist Doug MacGregor. (Above, SHMV; below, Island Store postcard.)

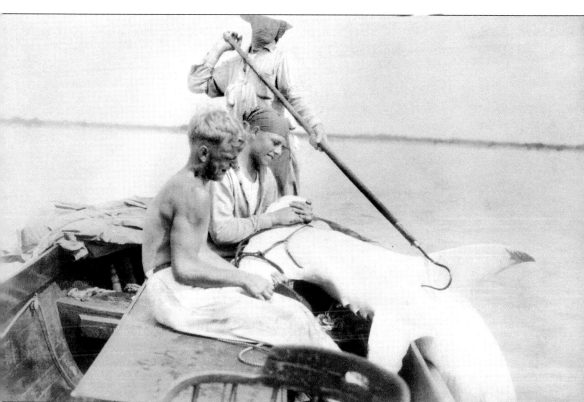

The capture of a giant hammerhead shark was reported in the *Fort Myers News-Press* on June 25, 1929: "Capture of a giant hammerhead shark weighing 980 pounds in whose stomach a whole tarpon was found was reported yesterday by a party of northern business men returning from a fishing trip. The enormous shark was harpooned and required the combined efforts of the six fishermen and two guides to land the monster. Members of the party also caught 51 tarpon and 3 jewfish weighing 250 pounds apiece. One of the tarpon caught weighed 176 pounds and is believed to set a record for the 1929 season." Here students from the Snyder School for Boys gaze at one such shark landed in the early 1920s. (FHC.)

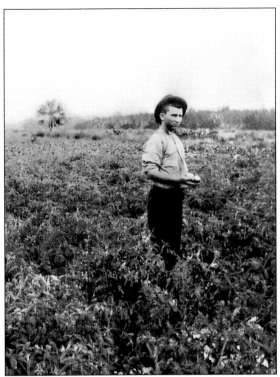

As captain on the yacht of Alice O'Brien—a wealthy lumber heiress from St. Paul, Minnesota, who had a home on Captiva—Belton Johnson tired of the demanding routine of the heiress and turned to farming, guiding, fishing, and odd carpentry jobs. An entry in *Twice Upon a Time* by Betty Hawkins refers to Johnson as affable and contented. He is said to have chortled, "Life is what you make it. After all, one man's steak and onions is a 'switch engine smothered in cinders' to a railroader." This photograph shows Johnson standing in a Sanibel tomato field in 1912. (SHMV.)

Inside Andy's Dock Store in the 1920s is Dessa, Andy's wife. Andy had been around Jug Creek at Bokeelia when he met Dessa Swuight and fell in love. In 1924, he took her in his boat to Fort Myers, where they were married. By the 1940s, Andy owned and operated the small store and commercial fish house on the sound at Captiva and catered to stray yachtsmen from the north. (SHMV.)

Erosion had not taken such a toll in the early 1900s along this sandy trail, now known as Captiva Drive. Running between the Gulf of Mexico to the left and houses sitting on properties stretching to the bay in the rear, the sandy trail was used by wagons and pedestrians. Tween-Waters Inn now occupies this stretch of Captiva Beach. (SHMV.)

For 37 years, Hattie Brainard Gore served as postmaster for the tiny post office on Captiva Island. Her cottage was modest, having only two rooms and floors made of sand. In contrast to the crude homemade pioneer furniture, her decor was accented with hand-painted china, sterling silver, and hand-carved frames, in which there were portraits of her family still residing in England and Canada. (SHMV.)

The Captiva schoolhouse, at 20 feet by 30 feet, opened on the Binder property in 1903. Mrs. T. M. Wilkinson taught 17 pupils as of January 1902. About once a month, a circuit preacher would hold services in the school. The school and church combined to celebrate Thanksgiving in 1903, with a dinner on the banks of Bowie Bayou, followed by a program at the school. Here a large unidentified group, possibly the church congregation, poses for a photograph outside the school building in the early 1900s. (SWFHS.)

Built in 1901, the Captiva Island School also served as a church on Sundays. Standing with her class at the one-room schoolhouse during the 1913–1914 school year, Nell Gould appears pleased with her students. Pictured (not in order) are Mary Hunger; Wilson and Jesse Bryant; Audrey, Ella, and Thelma Bates; Beaulah Brainerd; Chubb Mickle; Vera Brewer; and two Doyle girls. Absent that day were Betty Bryant and Margaret and Lucy Mickle. In 1964, the school merged with the Sanibel School, becoming the Sanibel-Captiva Elementary School, the first public school in Lee County to be totally integrated. (SWFMH.)

Although the population of Sanibel increased steadily, Captiva had few residents before 1900. The homestead of Judge Powell, whose brother had been part of the plot to assassinate Lincoln, was one of the earliest settlers. South of the Narrows, which became Redfish Press in 1921, there was only one resident, William H. Binder, who led a willing Robinson Crusoe existence from 1888 to 1898. Here a portion of the island as it was around 1900, with Captiva Drive barely visible between the homes and the Gulf. (SPL.)

Teddy Roosevelt's interest in wildlife led him to join the party of Col. Russell Coles, who was experimenting with tanning the skins of fish, such as sharks and manta rays. After arriving in Punta Gorda by train, he boarded a floating fish camp named the *Ark* that was later anchored in today's Roosevelt Pass. In 1917, the Ocean Leather Company was built on Sanibel, employing fishermen to catch and deliver sharks to the factory, where the skins were tanned, the livers rendered into oil, the fins made into glue, and the company carried out the brainstorm enterprise of Coles. Teddy Roosevelt is pictured to the right of Col. Russell Coles in this 1914 photograph of the two fishermen holding harpoons over a large manta ray. (BGHS.)

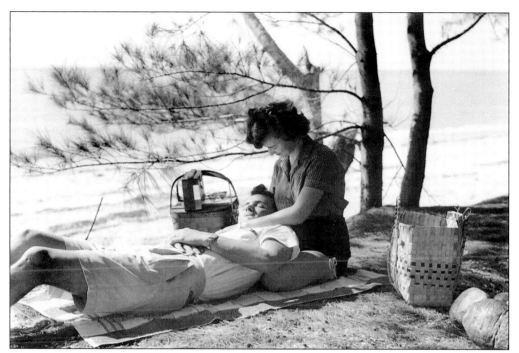

Photographed in January 1957, this unidentified honeymoon couple enjoys a private moment on Captiva Island. The accompanying note reads, "The peaceful solitude of Captiva is ideal for a honeymooner's picnic." (SAF.)

The pristine beaches of Captiva have attracted people for decades. Here unidentified people load wheelbarrows with Captiva's sand and shells for use at another location, perhaps Mondongo Island. These images were part of a book of images relating to Mondongo Island in the early 1900s. Of interest is the attire worn by the workers— knickers indicate a date of around 1915. If so, the women appear somewhat liberated for the time, with one wearing pants and the other a short skirt. (UIHS.)

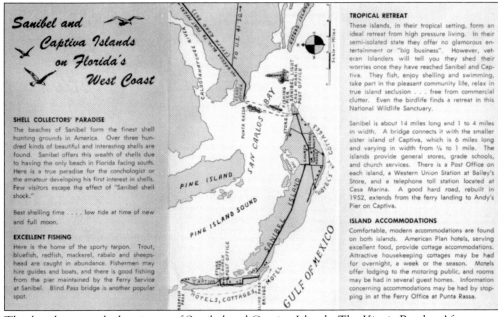

This brochure extols the virtues of Sanibel and Captiva Islands. The Kinzie Brothers' ferry route is shown on the map, dating it to a time before the completion of the Sanibel Causeway in 1963. The brochure boasts, "A telephone toll station at Casa Marina and a good hard road, rebuilt in 1952." Advice is given on the best shelling time—at low tide and a full moon. A fishing tip suggests trying Blind Pass Bridge. (SAF.)

A Captiva Island landmark since its establishment in 1979, the Bubble Room is one of Florida's most outrageous yet nostalgic restaurants. Memorabilia from the 1930s and 1940s are rolled into a Christmas, Hollywood, and toy-store experience. (Bubble Room postcard.)

South Seas Plantation's history can be traced to Clarence B. Chadwick, the inventor of the protective paper with overprinting that is used for bank checks. Chadwick purchased property on Captiva in the 1920s and planted a lime plantation that never thrived. In 1942, he sold the property for a hotel to be named South Seas Plantation. The 1974 aerial photograph shows the resort 30 years before Hurricane Charley all but destroyed it. The Carters' original frame house became part of the South Seas Plantation Resort, as pictured here in 1981. (SAF.)

Captiva, Fla.

A postcard from the early 1900s has written on the back, "Our guests, enjoying Captiva's beach." Playing in the surf during early summer along Captiva's and Sanibel's shores means doing the "stingray shuffle." Rather than picking up one's feet while walking in the surf, beachgoers shuffle through the sand and shells, alert to stingrays resting in the sand along the shore. Stepping on an unsuspecting stingray can result in a painful injury to the foot by the stingray's barb. (FHC.)

On early maps there appeared to be a neck of land called the Narrows on Captiva. In October 1921, a hurricane swept through the area, creating Redfish Pass. Elinore Dormer, in *The Sea Shell Islands*, believed it possible that this was the entrance by which the Ponce de León expedition entered the environs of San Carlos Bay in 1513. Redfish Pass lies to the south of Upper Captiva, while Captiva Pass lies to the north of the island. This bridge-free island, at 7 miles long and half a mile wide, is accessible by boat or plane. It remains without paved roads or throngs of tourists. (FHC.)

Four

SANIBEL ISLAND

Even with all the changes, I still can't think of another place I'd rather live.

—Capt. Bob Sbatino, *Every Day is Saturday*

Conchologists consider Sanibel and Captiva to be among the world's top three shelling locations, and in the Western Hemisphere, they are considered the best. While shelling is one of Sanibel's better-known attractions, it is only part of the island's character.

Sanibel Island, as well as the other Lee County islands, was within the realm of the Calusa Empire, as evidenced by the Wightman dig near Wulfert, Florida, in 1974. Here they examined excavated artifacts left by Sanibel's earliest dwellers. The first meeting between the Calusa and Spanish explorers took place, most likely, in 1513. Juan Ponce de León's log recorded a three-week stay on Sanibel's beaches before moving on.

Cuban fishermen arrived as early as the late 1600s. Their ranchos remained on Cayo Costa, Useppa, and Captiva, as well as Sanibel, until the early 1900s. Sanibel's first European settlers actually came by way of Key West. About 40 people arrived on Sanibel in 1833; however, the settlement was short-lived, disappearing by 1837.

By 1894, homesteaders had discovered Sanibel, bringing the population to 120 residents. Within two years, the population more than doubled to 300, with over 500 acres dedicated to farming. Today unique resorts, shops, and restaurants coexist peacefully with wildlife refuges and bird sanctuaries set aside by Sanibel's environmentally sensitive residents. The miles of white sand beaches continue to sparkle along the Gulf of Mexico. It is with the expectation of discovery that today's visitors practice the "Sanibel Stoop." As they become conchologists—on a temporary basis or as full-time resident collectors—Sanibel's history lives on in their footprints in the sand.

On August 20, 1884, the Sanibel Light Station was activated. The first lighthouse keeper, Dudley Richardson, climbed the 127 steps of the spiral stairway to reach the light. Rising to a 104-foot height, the Sanibel Lighthouse was braced atop a frame of open wrought iron. Around a flame, the gigantic French-made lens rotated by intricate clockwork. Scott Harris recalled his grandfather telling of the crew of a Cuban fishing boat seeking refuge in the lighthouse along with islanders during the storm of 1944. The family story quotes the grandfather saying, "I had to leer at those fishermen all night long. Your mother was just about sixteen and I had to protect her, you see." The lighthouse sits on the gulf side, while the pier is on the bay side in this early aerial photograph. (Both, FHC.)

Sanibel Lighthouse keeper Charles Henry Williams kept the light shining from 1910 to 1923. During those years, he ran a dependable schedule regardless of weather conditions. At the end of his Sanibel tenure, he moved to Gasparilla Island, where he ran the Boca Grande Lighthouse until his retirement in 1932. (SHMV.)

Originating at Punta Rassa, with stops at St. James City, Captiva, and Sanibel, the Kinzie Brothers Steamer Line's boat *Best* was captained by Leon Crumpler from October 1928 to 1963. The ferry transported passengers, horses, carts, and later, vehicles. The *Best* fares ran $1 per car or wagon and 50¢ for passengers. During the Great Depression, passenger fares were reduced to 35¢. (SAF.)

A family group approaches the Sanibel shore in a small boat around 1914. In the foreground, a young girl cradles an early Steiff teddy bear. First introduced in 1902 as a jointed bear, the German-made toy became known around the world for its ear button and mohair body. (FHC.)

Henry Shanahan became the second lighthouse keeper in 1892. His son, Webb, and daughter-in-law, Pearl (Rutland), built Palm Lodge, later known as The Palms. The hotel was located in a grove of Australian pines along the western shore just north of the lighthouse. Webb served as Sanibel's mail carrier, first on horseback and later by car. The hotel is shown in a pre-1936 photograph. (SAF.)

Former director of the Central Intelligence Agency Porter Goss, made Sanibel Island home as early as 1972. He was an active leader in the incorporation of the City of Sanibel and was elected its first mayor. Sanibel's first city council took office in late 1974. The council members are, from left to right, (standing) Porter Goss, Vernon MacKenzie, Charles LeBuff; (seated) Zelda "Zee" Butler and Francis Bailey. (SPL.)

In an open forum presentation held at the newly dedicated Bailey's General Store at the Sanibel Historical Museum and Village in June 1993, brothers Francis and Sam Bailey shared family stories: "John found a hose that looked like a tan snake with a black head. He put it in the drawer that held the teacher's 'whomping whip.' When she opened the drawer . . . well, they closed school for the rest of the day!" Born to Frank P. Bailey, the three brothers grew up on the island: "Daddy's first job was loading watermelon. Then, he became a truck farmer, raising tomatoes labeled, Sanibel Tomatoes. The original store was built in 1919." From left to right, Sam, Francis, and John sit on the family mule as young boys in this photograph. (Both, SHMV.)

In the late 1800s, Esperanza Woodring's maternal grandparents, Torbio and "Juanita" Laini Padilla, established one of the first fish rancheros in Southwest Florida. Here Esperanza (center) serves as a guide for a fishing party in Tarpon Bay near her Woodring Point home. Edwin Colby is at far right, and the stilt home of Harrison Woodring, Esperanza's brother-in-law, is visible at far right. (FHC.)

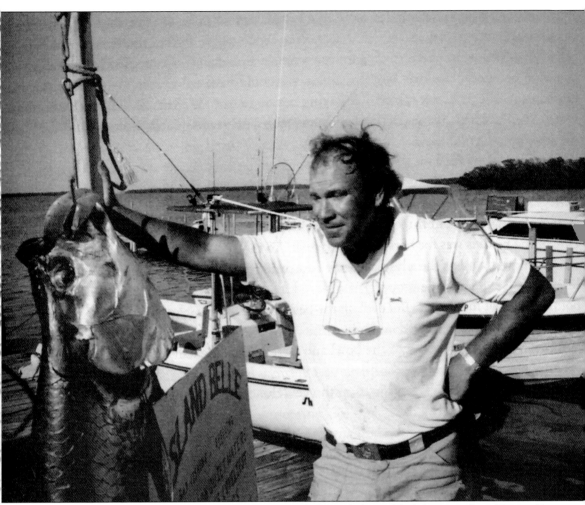

Best-selling author Randy Wayne White was a fulltime light-tackle fishing guide at Tarpon Bay Marina, Sanibel Island, for 13 years. White shared an encounter with another Sanibel fishing guide, the feisty Esperanza Woodring. White related Esperanza's complaint: "Some (expletive) guy came by me and my boat so (expletive) fast he about swamped us!" After further ranting about the incident from Woodring, White inquired, "Who was it?" She retorted, "Why, YOU, you (expletive, expletive)!" Not wanting to further alienate himself from Sanibel's legendary fishing guide, White replied, "I'm sorry." "Apology accepted," clipped Woodring. (Randy Wayne White.)

Grace Hall Hemingway, mother of Ernest and Carol, paints on a Sanibel beach, possibly at Blind Pass, in April 1921. In a letter on file at the Sanibel Library, John Sanford, nephew of Ernest Hemingway, wrote, "Uncle Ernest Hemingway wrote to my father in Sanibel on April 15, 1921: 'Get a good rest and some good fishing and go swimming for me. I surely wish I were with you.'" (SPL.)

Settling in Wulfert with her husband, Lewis, Jennie Doane became the postmaster and an advocate for women's suffrage. Somewhat eccentric, the couple kept their coffins at their home years before they were needed. Seances were held frequently with rumors of ghostly voices being heard. According to Elinore Dormer, "Robert Knowles, who lived on Buck Key as a child, recalled going with his mother to the Doane house and was served breakfast there—six walnuts rolling around on a plate." In this photograph is Jennie in the late 1990s. (FHC.)

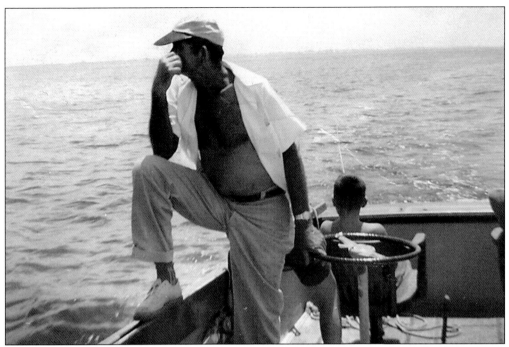

A Sanibel fishing guide, Jake Stokes enjoys a quiet moment on the *Islander* as the ferry crosses from Punta Rassa to Sanibel in August 1958. Grandson Scott Harris (right) recalled riding the ferry every summer when his family visited the island. The last run for the ferry service was May 26, 1963, the day the Sanibel Causeway opened. (Harris family collection.)

Dubbed the Sanibel Stoop, visitors and residents are seen parading along Sanibel's shoreline in a hunched-over stance, still popular into the 21st century. A group of early "stoopers" is seen in this 1910 image. Decked out in their Sunday best, they appear intent on finding a perfect shell for their collection. (FHC.)

Coon oysters can be found in the mangroves around most of Lee County's islands. Here two unidentified Sanibel islanders hold mangrove stalks with the tiny oysters attached. Preparation for eating included throwing the stalks in a fire and then, once they opened, digging them out of the cinders. "Eating the sweet delicate oysters was always a treat," according to Kay DellaBitta in a 2008 interview. (FHC.)

The first Sanibel Shell Shows were competitions between the winter residents at the Sisters Hotel (later Casa Ybel) and the Matthews Hotel (later the Island Inn). In the early days, only native shells were shown, and these were displayed on cotton in a cardboard box. One year, island produce was displayed along with Francis Bailey's chickens. The people shown in this 1908 photograph are believed to be the Tayntor family. (FHC.)

In 1889, while cruising aboard a sailboat in San Carlos Bay, Rev. George Barnes made an unplanned visit to Sanibel Island when he went aground on a sandbar. While awaiting the tide, Barnes felt divine inspiration to homestead on Sanibel. In 1890, Barnes built the Sisters Hotel, which was run by his daughters. Marie Barnes, most likely along with some Tayntor family members, is pictured in front of one of the hotel cottages in this 1908 photograph. (FHC.)

Mail call at the Casa Ybel resort was a highly anticipated event. Mail arriving in Southwest Florida made its first stop in Fort Myers. From there it was loaded onto mail boats servicing the islands. On Sanibel, the mail arrived at the bayside dock and was transported by horse and buggy to the gulf side of the island. Here Casa Ybel guests gather for the mail delivery. (SHMV.)

In 1910, Periwinkle Way was not congested with seasonal traffic moving at a gopher turtle's pace. Here the sand-and-shell road runs through native cabbage palms as it crosses the barren Sanibel plain. (SHMV.)

Not only was Emmy Lu Lewis an accomplished artist, as pictured here in 1980, she was also instrumental in establishing the "Ding" Darling Memorial Committee after Darling's death. To honor the Captiva islander, Pulitzer Prize winner, and ardent land conservationist, the committee worked for five years (1962–1967) to establish the J. N. "Ding" Darling National Wildlife Refuge. With the refuge established, Lewis turned to the establishment of the Sanibel-Captiva Conservation Foundation, a private organization protecting interior wetlands on the island. (FHC.)

In 1936, the Kinzie Brother Steamer Line added the *Islander* (pictured here), along with the *Rebel* and the *Yankee Clipper*, to their Lee County islands fleet of ferries. Pulling away from Punta Rassa in 1952, the *Islander* is loaded with vehicles, rather than the livestock, wagons, and supplies of earlier years. (FHC.)

Wild Cocoanut Trees, On Sanibel Island, Near Fort Myers, Fla.

Built by Rev. George Barnes in 1890, the Sisters Hotel was renamed Casa Ybel. In 1923, the hotel, including 360 acres of land, left the family when it was sold to Charlie Knapp for $19,000. Later the hotel was named Island Beach Club. In 1977, Mariner Properties purchased it for $2.4 million, at which time the name reverted back to Casa Ybel. While still owned by the Barnes family, this setting is what greeted Casa Ybel's guests. (SHMV.)

The photograph of this unidentified man and woman with a large alligator was taken around 1910 on one of Lee County's islands. Alligators like this one still prowl the islands, as evidenced by an alligator attack on Sanibel in June 2004. Janie Milsek, age 54, was attacked by a 12-foot-3-inch alligator while doing landscaping. She later died of injuries related to the attack. (SHMV.)

Five

ESTERO ISLAND

In general, tranquility reigned.

—Sue Davison, *Coconuts and Coquinas*

Estero Island and its sister island, San Carlos, make up the community of Fort Myers Beach. A Spanish word meaning estuary or inlet, *Estero* was a descriptive term found on old maps. It is thought that English-speaking people picked up the term as a proper name and applied it to both bay and island. Estero Bay was once the Bay or Harbor of Carlos, the chief of the Calusa Empire. It is a narrow island, 7 miles long and less than a mile wide. From the northwest point to the southeast tip, a gleaming white sand beach fronts the Gulf of Mexico. Today Estero Island, known as Fort Myers Beach, is a town of friendly citizens, artists, fishermen, and winter residents, with a healthy quota of welcomed tourists.

The first recorded settler, Robert B. Gilbert, was granted his homesteading patent by President McKinley in 1898. Development remained relatively slow on the island known as Crescent Beach until 1921. The first bridge, the Crescent Beach Bridge, was completed in that year. At 700 feet long, it connected what is now San Carlos Island (then still the mainland) with Estero Island. With the bridge came an insurgence of investors, tourists, and families seeking the good life of the economic boom.

In 1950, pink shrimp were found in the Gulf of Mexico, south of Fort Myers Beach in the Tortugas. Known as the "Pink Gold" of the 1950s, the shrimp industry brought a processing plant, shrimp docks with up to 150 shrimp boats, and numerous shrimp-related businesses to the island.

The condominium and timeshare high-rises began arriving in the 1960s, providing permanent housing and vacation lodging. By 1979, the completion of the Sky Bridge provided those desiring extended stays on Estero Island with the latest conveniences without the traffic congestion produced by the previous bridge. Desiring self-government, the Town of Fort Myers Beach became incorporated in December 1995.

On May 6, 1921, the first automobiles to cross over the Crescent Beach Road to Crescent Beach from Fort Myers paid a toll of 50¢, plus an 8-percent war tax, for a car with up to five people. An additional toll of 10¢ per person was added for crowded cars. With a life of only five years, the bridge was washed away in the 1926 hurricane and replaced with a concrete bridge. (SAF.)

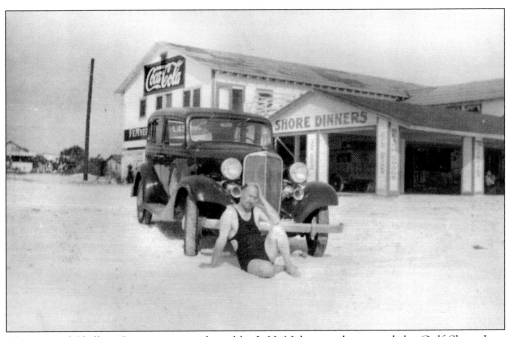

The original Phillips Casino was purchased by J. H. Nelson and renamed the Gulf Shore Inn. Adjoining the inn was Nettie's Place, one of the first restaurants on the island. Owned by the Pavese family, it was said to serve the best Italian food in Lee County. The Gulf Shore Inn was destroyed and Nettie's Place was severely damaged in the 1944 hurricane. This photograph was taken in front of the Gulf Shore Inn and Nettie's Place in the 1930s. (EIHS.)

In 1912, the Winkler Hotel was the first hotel built on Fort Myers Beach. Dr. William B. Winkler and his wife sold it in 1930, at which time the name was changed to Beach Hotel. This photograph shows Dr. Winkler in the early 1920s. (FMHM.)

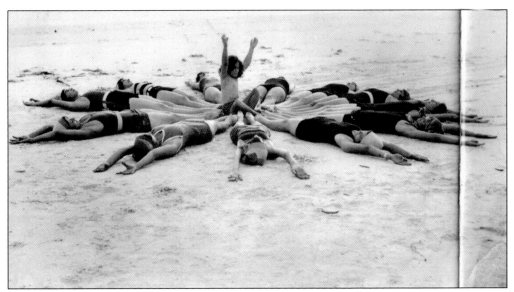

The inscription on the back of this photograph in the Southwest Florida Historical Society collection simply reads, "Mom at five years old on beach for a movie scene." The collection is filled with other photographs from Fort Myers Beach; therefore it can be assumed this picture was taken there. The girl in the middle is most likely "Mom." From the clothing, it was probably taken around 1915. (SWFHS.)

Built by Thomas H. Phillips in 1921, this 7,000-square-foot, two-story casino advertised modern bathrooms and an electric light plant. It also had a 100-foot boardwalk along the beachfront. The same year, it was destroyed by the 1921 hurricane, but it was rebuilt in 1923. Once again, it suffered destruction in the 1944 hurricane and was rebuilt. As in 1944, it is still known as the Gulf Shore Inn. (FMHM.)

MISS FT. MYERS. 1926 HOTGRA PHO
DOT 45

By the mid-1920s, Fort Myers Beach had become the casino and party destination for Southwest Florida. Not surprisingly, it was also a perfect place to hold a beauty pageant. Here Florence Thomason beams with joy at winning the title of Miss Fort Myers in 1926. (FMHM.)

By the mid-1920s, Fort Myers Beach was a popular destination for automobile day trips by the mid-1920s. On May 31, 1921, ninety-seven cars passed over the bridge—receipts for the day totaled $53. In addition to the casino, visitors could enjoy the beach by parking their cars on the wide, white sands. Visitors claimed Crescent Beach (Fort Myers Beach) to be equal to Ormond and Daytona Beaches. Here cars are parked along the beach in the early 1920s. (ESHS.)

These coquina rock arches were built by developer Tom Phillips in 1925 near the wooden toll bridge. The San Carlos on the Gulf development was located on what was then still part of the mainland. This narrow piece of land connecting San Carlos to the mainland washed away in the 1926 hurricane, creating San Carlos Island. The landmark arches were demolished in 1979. (SAF.)

H. A. "Bert" Waite purchased what was originally named the Winkler Hotel in 1930 and changed the name to the Beach Hotel. He also opened a restaurant on the pier in the late 1930s. Management of the pier changed several more times before it was badly damaged in a 1944 storm. Here the Beach Hotel and pier are shown in 1942. The black specks on the beach are cars. (SAF.)

The Gulf Air Trailer Park became one of the first travel trailer parks along the Lee County beaches. At a time when caravans of Airstream trailers pulled by big Bonnevilles traversed America's highways, this location was favored by many snowbirds. This early 1970 image shows the "no vacancy" popularity of the park. (EIHS.)

The first Beach School was formed in 1937 and was located in the Page Cottage on Chapel Street. With no street signs, the cottage homes were identified by the last name of the owner. Mrs. Page rented her cottage to the school for $27 per month. The following year, a two-room building was constructed. (EIHS.)

By 1947, the elementary school had outgrown its usefulness, and property was purchased in the Windler subdivision on Oak Street for a new school. An auditorium and six classrooms, plus an office, were housed in a wooden school building relocated to this property from Bayshore Road in North Fort Myers. In 1948, the school officially opened. (EIHS.)

In 1893, Dr. Cyrus Teed, referred to by his followers as Koresh, arrived on Estero Island with the intention of setting up his religious community known as the Koreshan Unity. The religious maintained a novel concept of the earth, believing everyone lives on the inside of a hallow sphere. Surprisingly, the theory is nearly proven to be true in a book by Koresh, The Cellular Cosmogony. Although he decided to start the community on the mainland of Estero, he also purchased large acreage holdings on Estero Island and established a sawmill on the island in 1894. Teed stands with a large tarpon in this 1890s photograph. (EIHS.)

A concrete road, running from north of the Fort Myers Beach landmark arches to the pier, was laid in 1926, becoming part of San Carlos Boulevard. George Dupuy, the Lee County supervisor of roads, managed the crews. Here a crew is at work on the road. (FMHM.)

This concrete bridge with a steel wing was built in 1928, after the original wooden toll bridge was washed away by the 1926 hurricane. The bridge was not replaced until 1979, when it was demolished after the completion of the Sky Bridge. The sign on the San Carlos Inn to the right reads, "Chicken Dinner—$1." Remnants of the wooden bridge are in the far right of the image. (SWHS.)

By 1950, sweet shrimp, referred to as "pink gold," was discovered in the Tortugas. Soon as many as 150 shrimp boats made Fort Myers Beach their homeport, bringing in a new source of income for the island. According to Rolfe F. Schell, in the History of Fort Myers Beach, Florida, 17.32 million pounds of shrimp were being caught and brought into the island port by 1953. At the time, it was enough to give every resident in 24 cities the size of Miami a pound of shrimp. Here the Columbia Fish Company docks are lined with shrimp boats. (EIHS.)

In December 1952, Blessing of the Fleet ceremonies began on Fort Myers Beach. The formal blessing was conducted by Episcopal priests and held at the Columbia Fish Company docks. In this 1960s photograph of the blessing ceremony, the new concrete bridge is in the background. Also present (far right) are an unidentified bride and groom wearing their wedding attire. (EIHS.)

Estero Islanders Murray Thwaites and Jeff Brame were responsible for starting a mosquito control operation. In 1946, the two solicited funds from the property owners association by pledging $100 each. They then showed the list to other more affluent residents who matched Thwaites's and Brame's pledges. Soon there was enough money to get the program started with an orchard sprayer and an old surplus army Jeep. Here in 1949, a mosquito control plane fogs the air with repellent. (SAF.)

By the end of 1903, the Koreshan headquarters had been moved from Chicago to mainland Estero and Estero Island. Posing for a group photograph on Fort Myers Beach around 1910, these Koreshan Unity members are prepared for a fun day in the sun. (EIHS.)

In 1947, yet another hurricane hit the island. Along with dozens of homes and docks damaged or destroyed, Nettie's Place was badly damaged. Resident Hugh McPhie said of the aftermath, "Estero Boulevard was so quiet in 1947, you could hear gophers (land turtles) chomping on grass 50 feet away." Here two girls check out a truck bed of gopher turtles awaiting "Gopher Races" as part of Shrimp Festival activities in the early 1970s. (EIHS.)

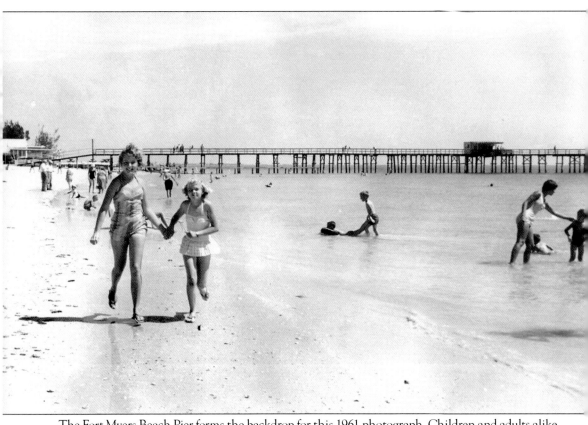

The Fort Myers Beach Pier forms the backdrop for this 1961 photograph. Children and adults alike are enjoying the warm Gulf of Mexico water or playing in the sand. The exuberance of childhood freedom and innocence is evident in the two unidentified girls running on the beach. (SAF.)

Six

Pine Island

A visit to Pine Island is a step back into Florida's past.

—Nancy Brooks

Nestled between the outer islands of Cayo Costa, Captiva/North Captiva, and Sanibel, Pine Island is the largest island on Florida's western coast. At 17 miles long and 2 miles wide, Pine Island has a heritage that is a bit different from the neighboring islands. Rather than sandy beaches, the mangrove estuaries fringing the shoreline have attracted fisherfolk and sports-fishing enthusiasts in place of sun-worshiping purists. The temperate climate has been ideal for agriculturists' fields of tropical fruits or palms, giving the island an air of timelessness. Unlike the other islands, five independent communities comprise the Greater Pine Island area: Bokeelia, Pineland, Matlacha, the Center, and St. James City.

Calusa Indians were Pine Island's first inhabitants. Col. Donald and Patricia Randell donated 56 acres of Calusa Indian mound land at Pineland in August 1994. Named in honor of the initial benefactors, the Randell Research Center consists of 200 preserved acres. On his final voyage exploring Florida in 1513, Ponce de Leon eventually died from injuries inflicted during a battle with the Calusa Indians along Pine Island's northern shore. On the southern end of Pine Island, a group of out-of-state developers formed a company in 1885 with plans to establish a planned community development. Named St. James-on-the-Gulf, it was the first known "subdivision" in Southwest Florida. Nearby Fort Myers was not yet incorporated, while Miami was not yet developed, when St. James City became incorporated August 12, 1885.

The protection offered by the outer islands provides a fishing and boating paradise. The abundance of fish, crabs, and shrimp that attracted the Calusa Indians to the area several hundred years ago, followed by commercial fishermen of the 20th century, continue to attract sports fishermen. With no traffic lights, visitors to Pine Island discover it is a step back in time and are captivated by her Southern charm and sultry beauty.

This early island resident rides in a horse-drawn buggy across what was called "the old humped-back" bridge over Jug Creek. Most likely, he is heading to the Bokeelia post office around 1918. During Prohibition, the supporting beams beneath the bridge provided an ideal place for tying rum-filled jugs, allowing the jugs to rest in the cool water, well away from the eyes of authorities. Around 1945, the bridge was moved 60 yards west of this location, straightening the North-South Stringfellow Road. (Honc family collection.)

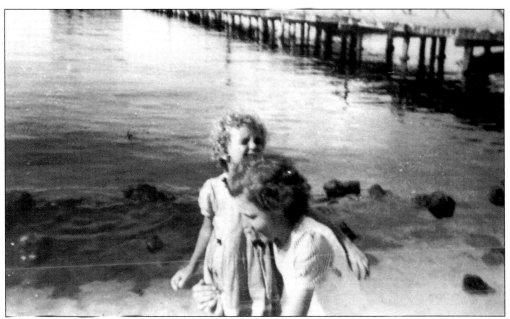

Bokeelia's first settlers, Henry and Minta Martin, arrived by way of Pineland in 1904. An attendant slept in small living quarters adjoining the fish house built by Martin on the end of the pier. Run boats docked here, delivering supplies to Pine Island settlers and picking up fish bound for northern markets. The run boats also served as a mode of transportation to Pine Islanders heading to the mainland. Two children play at the foot of the pier in the 1920s. (SWFHS.)

Mail boat operator Capt. Thomas Willis wrote of the 1920s in his journal: "Back in those early days, motor boats had just started being used. It was still common to see out on the bay several fleets of sail skiffs—five or six in a bunch. They would sail till they saw a big shoal full of mullet, then take down their sails and pole out and strike the fish. They would fill and heap up their boats. Then they put up their sails and sailed back to their fish camp. They would get about one cent a pound for mullet then, but they lived fatter and easier than since higher prices and less fish." Skiffs like this one were popular in Charlotte Harbor and Pine Island Sound until the advent of the powerboat motor around 1910. (BGHS.)

The family of Vincent Joseph Honc and his wife, Ludmilla Elizabeth Sushil Honc, are shown in 1935. Pictured are, from left to right, (first row) John Patrick, Agnes Aileen, Vincent Jerome, and Margaret Theresa (Sister Kathleen Francis); (second row) Marie Agnes, Ludmilla (Milla) Frances, Elizabeth Marie, and Augusta Anna (Sister Vincent). Also shown are parents Ludmilla and Vincent, on each end. (Honc family collection.)

By 1920, Pine Island mangos were famous all over the country, thanks to Vincent Honc. With the help of Capt. John Smith, Frank Danials, and Harry Poe Johnson, mangos became a lucrative business. With her seven daughters, Ludmilla canned jars of mangos for the family's mail-order customers. One of her notorious customers was Ringling Brothers Circus owner John Ringling. Here Honc is shown with a mango tree in the 1920s. To honor the mango production on Pine Island, Mango Mania is held each summer. (Honc family collection.)

Trained in grafting in his native Moravia, Vincent Honc worked with Everglade Nursery in Fort Myers before starting his own operation on Pine Island. At Honc's avocado nursery, he grew grapefruit, avocados, and mangos on 30 acres near the Jug Creek Bridge in Bokeelia. Honc's grafting technique is pictured here, with a scaffold built within a mature mango tree to hold the pots for the grafted branches to root. The grafted branches were not cut from the tree until fully rooted. The year 1932 wrought untold havoc—a salt tide that destroyed the major part of his nursery, the Depression, and a plague of mosquitoes—yet he persevered. Honc stands on the top layer of the scaffold, while his children sit on a lower level in this image, taken in the 1920s. (Honc family collection.)

Vincent and Ludmilla Honc built this traditional "Cracker" home on the north end of Pine Island around 1918. Raised off the ground, Cracker houses were basic one-room "single pen" designs, which had a chimney and allowed for expansion. Jack the mule was the Honc family's only mode of transportation until 1926, when they purchased their first car. Devout Catholics, they attended mass in Fort Myers, the nearest Catholic church, once a month. Taking their seven daughters and two sons on this quest was an ordeal. First they met the run boat at Martin's Pier in Bokeelia early Saturday morning; then, after crossing Charlotte Harbor, they transferred to a train that took them to Fort Myers. They stayed in a downtown hotel on Saturday night in order to attend the hour-and-a-half service on Sunday morning. After the service, they reversed the trip, arriving home on Monday morning. Pictured above are, from left to right, Jack the mule, Ludmilla, two unidentified women, and Vincent (standing). (Honc family collection.)

Bringing power to Pine Island in 1949, this Lee County Electric Co-op crew sets an auger for installation of electrical poles. Later, power would be provided by the co-op to all of Lee County's outer islands. Pictured here in 1959 are, from left to right, Oscar McClenithan, Hulon Futch, Ellibie Payne, and Pete Howel. Harry Celec recalled working with these men, along with Pete Jeter, a line foreman. Ruby Gill, Pineland's postmaster, was instrumental in Celec getting his first job as a lineman with the Lee County Electric Co-op. (FMHM.)

In 1926, work began on a wooden bridge across Matlacha Pass. It, along with a series of smaller bridges, linked Porpoise Island with Little Pine Island and Big Pine Island. The fill dirt from dredging for the bridge construction provided land for houses and businesses. Almost overnight, the town of Matlacha appeared along the fill. The 1960s Elvis Presley movie *Follow That Dream* (based on the book *Pioneer Go Home* by Richard Powell) immortalized these squatters and the causeway. It was not long before it became known as the Fishingest Bridge in the World. Fishing enthusiasts still line the bridge, just as these fishermen did in the 1940s. (FMHM.)

Gay and George Kuhns moved to the island in 1929. In a 1982 interview, Gay recalled, "There was just one other family living in Matlacha. We carved ourselves a place to live out of the mangrove swamp, pitched a tent, and started to work. We went to fishin' and didn't know a thing about it. We learned quickly. One night, I remember in less than two hours, I caught 38 snook and my husband got 49. It was a haven for fish then." (*Fort Myers News-Press*, April 18, 1982.)

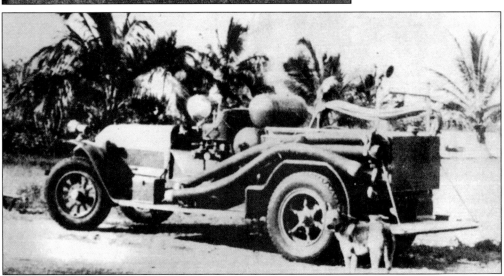

In 1955, a group of men formed the Volunteer Matlacha Fire District with Buck Mims as the chief. The first piece of equipment was a 1924 La France fire truck purchased for $1 from the Fort Myers Fire Department. With the truck stationed in Matlacha, a fire run to Bokeelia, St. James City, Pine Island Center, or Pineland would prove to be a real adventure. Every eight blocks the engine overheated and would blow the freeze plugs out. The men would climb down, pour in water, hammer in new plugs, climb back in, and drive another eight blocks, where the scenario would be repeated. Perhaps this process explains a comment made by a later fire chief, Marty Slater—"I don't think we ever paid them the dollar." (SWFHS.)

The United Mine Worker's Union president from 1920 to 1960, John L. Lewis was one of Pineland's more famous personalities. First he enjoyed staying at the Pine-Aire Lodge, but later he purchased this home on a Pineland Calusa mound. Lewis enjoyed his time in Pineland, referring to it as "getting away from it all." A common sight of the time is visible on the right side of the image: a tower for collecting rainwater. (FMHM.)

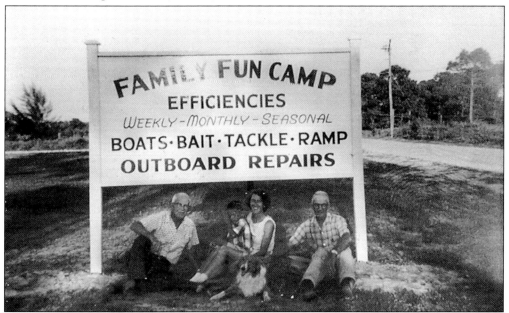

The Family Fun Camp on Pine Island offered a laid-back atmosphere for family vacations. Here George Edmond and his daughter Florence Clay, grandson Gordon, and son-in-law John (Pop) sit beneath their business sign in 1966. The Clays were instrumental in making the Pine Island Volunteer Fire Department a success. Florence would arrive at every fire, providing ice water for the volunteers. (MOTI.)

In 1911, brothers Ernest, Fred, and James Hord moved their families to Pine Island during the building of the Sisal Hemp plant at St. James City. Hundreds of acres of sisal were grown for the hemp rope production. By 1913, the factory was in full operation; however, the factory closed in 1915, when production costs were found to be far less in the Yucatan. Known as the Hord Mansion, this elegant home was built by James and Eunice Hord. (MOTI.)

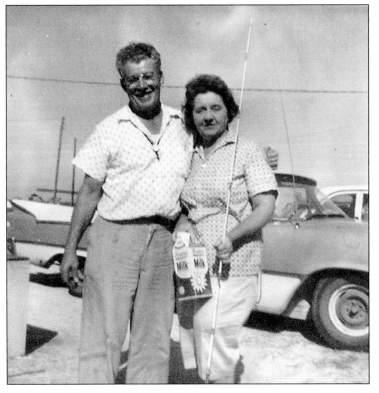

Don and Marthabelle Jedlick are shown here about the time they moved to Pine Island in 1961. Fishermen in the area would deliver their fish to the St. James City fish house, Jedlicks, where they would be given a ticket with an amount of credit based on the weight of fish sold. The Jedlicks would sell food and supplies to the fishermen, after which Marthabelle would drive approximately 10 miles to Jesse and Velma Padilla's icehouse/store to trade the tickets for cash. (Jedlick family collection.)

Referring to his commercial fishing days of the 1930s, Floyd "Tootsie" Barnes said, "I'd get up and get out on the water long before dawn and lay 250 yards of net by hand. Our nets were all cotton and linen with cork made from bark. I fished every day, and it didn't matter if it was raining, freezing cold, or hot. On a good day, I'd pull my nets by hand with as many as 600 pounds of mullet, earning as much as 3 cents or 4 cents a pound." Barnes is pictured here in the February 1998 interview. Nets like the ones Tootsie referred to are in the Bokeelia photograph below. The net-spreads were a common sight on the Lee County islands throughout the 1920s. (Right, MOTI; below, BGHS.)

In 1923, Pineland residents worked with the Methodist Mission Board to build the first church on the island. A minister commuted from Boca Grande by mail boat once a month to hold church services. As the population spread across the island, the church relocated to the central location of Pine Island Center, where it is presently located. Once abandoned by the Methodist Church, Joe Celec purchased the building and converted it into his family's home. (SWTHS.)

As a young bachelor, Jimmie Howard moved to Bokeelia in 1906. Single females were a scarcity, so he met his Georgia bride through the postal system. The two only corresponded through the mail until their marriage. Eventually celebrating 60 years of marriage, the Howard family is shown in front of their Pine Island home in 1948. They are, from left to right, (first row) Julia Belle, Lonnie, and Jack; (second row) Alfred, Lilly (mother) holding Nellie Mae, and Jimmie holding David. (Howard family collection.)

Fishing as a livelihood was a way of life for the majority of the Pine Islanders for many years. Telling of the earlier days of fishing, Alfred and Jack Howard said, "Up on Tortuga (Bokeelia) our grandmother lived in a lightern, and then all the way to the water was net spreads. What a sight! We couldn't leave the nets on the boats or they would rot." Alfred, at age 17 in 1947, comes in with a day's catch in this photograph. (Howard family collection.)

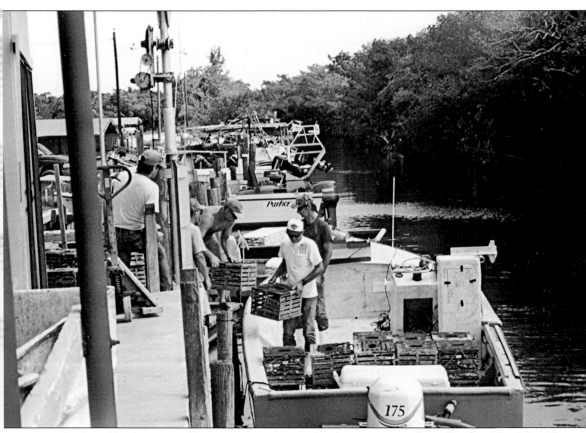

On Pine Island, stone crabbing remains a seasonal industry, running from October 15 to May 15. Crabbers take just one of the two claws on the stone crab and return the live crab to the water, allowing it to grow a new claw. In this way, the crab and crab fishermen continue the life cycle of the industry. Unidentified Pine Island crabbers are unloading crab traps at the Maria Drive Fish Co-op in the 1990s. (Dooley family collection.)

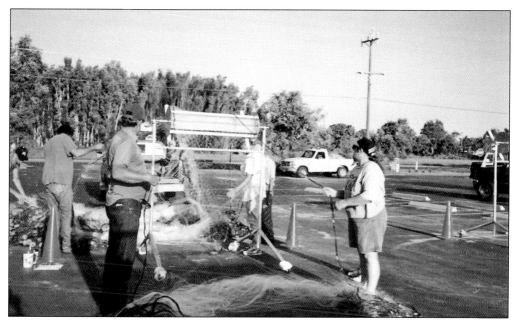

Mullet remained a major commercial industry on Pine Island until the net ban went into effect in 1995. The center of the U.S. commercial mullet fishery was Charlotte Harbor, which produced over 24 million pounds annually, according to Robert Edic in *The Fisherfolk of Charlotte Harbor, Florida*. Here Pine Island fishermen turn in their nets to government agents in the wake of the net ban. (Dooley family collection.)

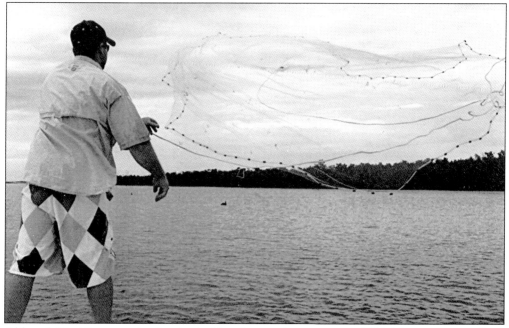

Although Floridians voted to ban both gill and entanglement nets in 1994, fishermen may still use both cast nets and seine nets. A cast net is a circle of knotted monofilament line with lead weights sewn to the circumference. Here Pine Islander Craig Stevens throws a cast net in an effort to catch a supply of baitfish during a day of fishing on Pine Island Sound in 2003. (Author's collection.)

In 1950, the community of Matlacha had grown to include permanent wooden homes along the fill area leading to the wooden swing bridge. The swing section is shown on the far side of the bridge in this image. People fishing along the sides of the bridge are also visible as tiny white dots. (FHC.)

Creative juices seem to pulse through the veins of Pine Islanders at a higher than normal rate. Now labeled the "New Key West," the brightly painted cottages and businesses of Matlacha are home to artists, musicians, and writers. Galleries, restaurants, and gift shops are interspersed with fish houses and marinas throughout the island. Greater Pine Island resident Robert Macomber is the award winning maritime author of the popular Peter Wake series as well as a lecturer and television commentator. (Pineapple Press.)

Frank and Kay's Fish Camp, owned by Frank and Kay DellaBitta through the mid-1900s, was located on Jug Creek. They offered "boat rentals, bait, tackle, gas, oil, boat ramp, covered dockage and friendship." Later sold by the couple, it became Four Winds Marina, as shown here. (DellaBitta family collection.)

In "Caught on a Lee Shore," an excerpt from the diary of Lt. William Henn included in *Tales of Old Florida*, the lieutenant tells a colorful story of tarpon fishing at the mouth of the Caloosa River in 1890. At St. James City, the lieutenant and his wife would have stepped onto Whiteside's Dock and most likely stayed at the three-story San Carlos Hotel, boasting 50 guest rooms, during their stay. The ironwork seen here on the San Carlos Hotel porch rails was created by Pine Island resident Sam Woodring. By 1905, the hotel had been abandoned, and Sam Woodring had moved to Sanibel Island. (SWFHS.)

Ernie Long was a happy, harmless, hard-working-yet-lazy sort of guy. He could walk barefoot across an oyster bar with not so much of a scratch on his feet. He would readily say that the only thing to hurt him was wearing shoes. He could recall when just six families lived in Matlacha. Shown here in 1982, Ernie said of those earlier days, "There were no roads and only one line of work. If you didn't fish, you didn't live." (MOTI.)

Florence Hiltbrand and her husband moved to Pine Island in 1917. Living in Bokeelia, they had no communication with the outside world except by boat. When she started out on the 2-mile walk to the post office, she said, "I never knew if I would arrive wet to the waist, for the tide water came across the road every high tide." Here Florence and her husband, Herman, reign over Pine Island's Bicentennial festivities on July 28, 1976. (*Pine Island Eagle.*)

KINZIE BROTHERS STEAMER LINE. Daily to the Gulf

Leave 8:00 A. M. Return 6:00 P. M.

FINE SHELL BEACH — FISHING — BATHING. Special Trips on Sundays

Steamboats owned by the Kinzie Brothers Steamer Line served Lee County's islands, including Pine Island, until May 26, 1963, when a Kinzie Ferry made a final symbolic run as the ribbon was cut on the Sanibel Causeway span above. Also responsible for water transportation between the mainland and the islands were brothers J. Fred and Conrad Menge, who operated several stern-wheelers. (SWFHS.)

Seven

USEPPA ISLAND

Useppa . . . the most beautiful island in the area.

—Barron Collier

Continuously inhabited for over 7,000 years, Useppa Island was home to nomadic peoples who roamed in search of food in prehistoric times. Some 7,000 years ago, the Calusa civilization arose to become one of the most sophisticated native societies to have evolved in North America. Useppa became a major stronghold of the Calusa Empire. Several archeological digs have been conducted on the island. Calusa artifacts can be found archived in the Useppa Island Historical Society's museum. Within 200 years of the arrival of European explorers, including Ponce de León in 1513, the Calusa culture had become extinct and faded into history.

After Spain ceded Florida to the United States in 1819, the Florida Legislature planned the island's development, including the takeover of Useppa's fishing grounds from Jose Calez, a Cuban fisherman living on the island. Naming the island after his uncle, Caldez is credited with calling the island "Tio Sespes," which is clearly documented in the first deed of Useppa. Following the three Seminole Wars, in July 1833, U.S. Customs agent Henry Crews came to live on Useppa. In 1836, Useppa was attacked by 25 Seminoles while Caldez and his men were fishing, after which Caldez returned to Cuba. In hopes of stabilizing the area, Fort Casey opened on Useppa in January 1850. Three years after the Seminole Wars ended the Civil War began. Local men who believed in the Union cause sought refuge on the island, aiding the Union ships.

Useppa Island was purchased by John M. Roach, a Chicago mass transit magnate, in 1894. With the advent of tarpon fishing only a few years earlier, Roach's friends convinced him to build a hotel on Useppa so they could also share in the prize fishing grounds. In 1911, Barron Collier purchased the island from Roach and turned it into a classy turn-of-the-century getaway for industry giants, political bigwigs, and Hollywood celebrities. The island was later abandoned and used by the U.S. government for Bay of Pigs training exercises in 1961.

With a desire to restore the island to its former elegance, Gar Beckstead, along with 14 partners, purchased the island in 1973. Beckstead became the sole owner in 1990. Today Useppa is recognized not only for its restored grandeur but also for the charm its history dictates.

In 1912, Useppa Island was Barron G. Collier's first land purchase in Southwest Florida. He eventually owned over a million acres of Southwest Florida land, making him Florida's largest single landowner in the 1930s. After Collier died in 1939, Useppa slowly went downhill. Shown here is Collier with wife Juliet Gordon Carnes on a boat deck off Useppa Island. (BGHS.)

Boca Grande Pass was a congested waterway in 1915. Pictured is Barron Collier's private steam yacht, Useppa. It regularly dodged four-masted schooners, tugboats loaded with phosphate, chartered sports fishing boats, and fisherfolk smacks as it ferried visitors between Useppa Island and South Boca Grande. (BGHS.)

In the April 9, 1885, issue of *Forest and Stream*, the magazine announced, "A Mr. Wood of New York took last week a tarpon measuring 5 feet 8 inches and weighing 68 pounds, tackle rod and reel." Before the ink dried on the news, the waters from Boca Grande to Punta Rassa became the hot spot for tarpon anglers. By the year 2000, a typical 80-day season produced an average of 5,000 tarpon landed in the best tarpon fishing hole in the world. Here in May 1921, a Useppa Island guest, angler F. J. French, displays his tarpon catch, weighing in at 165.5 pounds. (SAF.)

The nearly abandoned Useppa Island became a strategic CIA training site in 1961. The men arrived by plane or aboard the *Roving Gambler*, launching from Pine Island. The Bay of Pigs Invasion began on April 17, 1961. The men, part of Brigade 2506 who took part in the invasion, are shown here while in attendance at a Bay of Pigs Reunion hosted by Useppa Island in November 2007. The other image is of the *Roving Gambler*. (Above, UIHS; below, FMHM.)

According to fishing guide Capt. Robert McCue, "The tens of thousands of tarpon that visited Boca Grande Pass during earlier times still come today. For those sportsmen who have never witnessed this phenomenon, it is something that must be experienced to be believed. It is tarpon fishing second to none!" Strategically located near this fisherman's dream fishing ground, Useppa has provided lodging for many international guests. Here H. Taylor of London poses on Useppa's dock with his prize tarpon in 1912. (FMHM.)

America's most famous reel maker, Edward vom Hofe, was a friend of John Roach and frequent Useppa visitor. Allowing a small person to land a large fish, the star drag reel invented by vom Hofe was the beginning of modern sport fishing. One of his star drag reels, dated 1867, is displayed in the Useppa Island Historical Museum. Edward vom Hofe is shown here while on a Useppa Island visit. (UIHS.)

Barron Collier is credited with founding the Izaak Walton Club, named for the English author who penned *The Complete Angler*. As one of the first books on saltwater fishing, Walton's book had run to five editions by the end of the 17th century, according to Dunn and Goady in *Salt Water Game Fishes of the World*. The Izaak Walton Club became so popular that 15 to 20 fishing guides were employed by 1915 to handle the influx of tarpon anglers. The interior walls of the club, as seen here in 1938, were covered in large tarpon scales, representing one catch per scale. (UIHS.)

As the finest fishing club of its time, the Izaak Walton Club's buttons were highly prized. Tarpon fishermen received a silver button for the first tarpon caught; a 100-pound tarpon netted the angler a gold button; and a 150-plus-pound tarpon merited a diamond button. The award of these buttons led to the practice of releasing tarpon, with the exception of those that had to be weighed for awarding the buttons. (UIHS.)

Mary Roberts Rinehart wrote 54 mystery novels and 5 plays between 1909 and 1952. She was the best-selling and highest-paid U.S. author for nearly 50 years. Rinehart spent her winters in her cottage on Useppa's northern shore, with her son and family on Cabbage Key, or aboard her 28-foot cabin cruiser, the *Greyhound*. Here Rinehart shows off her prize tarpon catch on Useppa Island. (UIHS.)

In 1968, while looking for a deep-water dock for his 72-foot boat, *Big Toy*—the world's largest fiberglass sailboat of the time—Jim Turner purchased Useppa Island from William Snow. Desiring peace and quiet, Turner did not allow children on the island, unlike today. This aerial photograph shows the deep water surrounding Useppa Island, as well as the iconic Collier Inn and Dock in 1950. (FHC.)

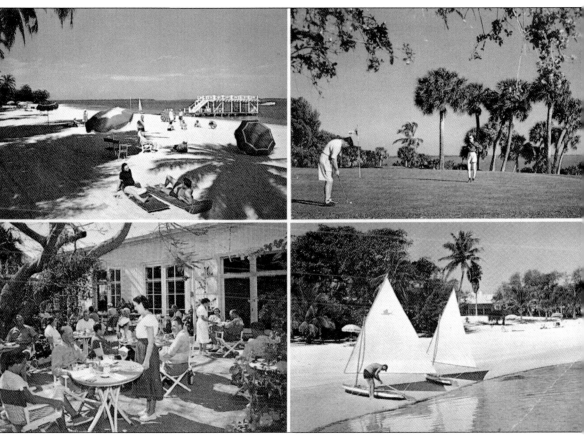

The back of this 1960s postcard reads, "Last season, Useppa Island Club had a distinguished guest list which included 8 presidents of banks, 22 presidents of business companies, 2 government officials, and one governor." These prominent men and their families found Useppa Island an ideal place to relax as if it were their own winter home. (FMHM.)

In addition to world-class fishing, Useppa Island also boasts a well-maintained regulation six-wicket croquet court. The G. Robert "Bob" Sumwalt Croquet Lawn is an asset to the island. The lawn plays host to numerous tournaments throughout the year. Dressed in requisite white are competitors on the Useppa court. (UIHS.)

Useppa Islanders developed a competitive golf team under Barron Collier's ownership. Shown here around 1915, the team of 12 is dressed in knickers, jackets, ties, hats, white hosiery, and golf shoes. The first hole of the island's golf course was known as the Camel's Back and overlooked Pine Island Sound. The 2,100-yard, nine-hole golf course is no longer on Useppa, replaced by island dwellings. (FSA.)

The picturesque Pink Path, winding around Useppa's shores and through its center, is lined with massive moss-draped oaks, huge palms, and a mammoth banyan. Cars are not allowed on the 80-acre island. At almost 100 years old and constructed of super-hard Dade pinewood, the cottage featured here was once owned by Barron Collier. It was built in 1912 and is one of the five original houses still standing. The cottage is currently owned by Bob and Karen Long. (FMHM.)

Garfield Beckstead was a partner in the new Useppa Land Trust, along with Mariner Properties and 14 other partners, when Useppa was purchased from Jim Turner in 1973. Eventually Beckstead bought out the other partners and became sole owner of the Useppa Inn and Dock Company. Honoring the 30th anniversary of modern Useppa is the Beckstead family: Garfield and wife Sanae, with their children Mika and Donald. (UIHS.)

Because of its intriguing past, Useppa attracts an abundance of history buffs. The Barbara Sumwalt Museum, originally built as a Useppa cottage, houses a first-class collection of island artifacts. Through the vision of Barbara Sumwalt and the assistance of many island residents, plus the generous donations made by Useppa Island Club and the Useppa Island Historical Society's members, the building was moved, reconstructed, and opened to the public in 1994. (UIHS.)

Useppa's Collier Inn is shown on this 1960s postcard. On the beach in front of the building is the plane that was used to fly guests from the Fort Myers airport to this remote island. The Republic Aircraft Corporation manufactured the RC-3 Seabee between 1946 and 1948. Designed by Percival Spencer, the aircraft was ideal for the commute between the Florida mainland and Useppa Island, as it was an all-metal, amphibious plane. William Snow built the airstrip during the time he owned the island from 1962 to 1968. (FMHM.)

Eight

LEE COUNTY'S KEYS AND MINOR ISLANDS

Once you discover paradise, you'll never want to leave.

—Lee Thomas

Within the sheltered waters of Pine Island Sound and San Carlos Bay lie Lee County's smallest islands, or keys. In 1895, Frank Hamilton Cushing made an extensive tour of the mounds. He reported that there was evidence of Calusa Indians living on many of the islands as early as 500 BC. Mound Key, like some of the other mounded islands, is man-made. It was built by men and women carrying baskets of woven palm fronds filled with shells from the nearby shallow bay waters. Demere Key, lying off Pine Island's western shore, is thought to have been a Calusa Indian worship center. Buck Key, also a Calusa mound, was named for the large deer that frequented it.

Lofton's Island might lack the glamour of the barrier islands, but it has a unique past. Lying between the Edison and Caloosahatchee Bridges, the island was created from spoil in the early 1900s, when the Caloosahatchee River was dredged to form a turning basin for steamers, such as the *Dixie*, heading to the outer islands. Galt Island and Connie Mack Islands are both home to luxurious homes overlooking tranquil waters. Inspired by the island's menu specialty, Jimmy Buffett penned his hit song "Cheeseburger in Paradise" on Cabbage Key.

Among other islands nestled in the protected waters are Patricio Island, the site of extensive gardens producing fresh flowers for Useppa's Collier Inn, and Burgess Island, once the home of Charles F. Burgess, the inventor of the dry-cell battery and flashlight. Visitors to Estero Island often enjoyed an outing to Hickory Island, known as Hickory Isle in the early-1900s song "Lover's Key." Accessible only by boat, these islands have retained the ambience of an unspoiled paradise.

Punta Rassa, strategically located at the mouth of the Caloosahatchee River, has maintained continuous occupancy for many centuries. Its present name, without the extra "s," is Spanish for "flat point." Along with other historians, Elinore Dormer, in her book *The Sea Shell Islands*, wrote that the old Calusa town of Muspa was probably located there. The grocery store pictured above was the final stop for mainland supplies for those boarding a steamer, ferry, or boat for the Lee County islands. (SHMV.)

A 1940s advertisement in the *Fort Myers News-Press* offers Chino Island as the perfect site for a fishing camp. Strategically located within Pine Island Sound, it is well protected from storms but close to some of the world's best fishing. At only $3,500, it was a bargain. (*Fort Myers News-Press*.)

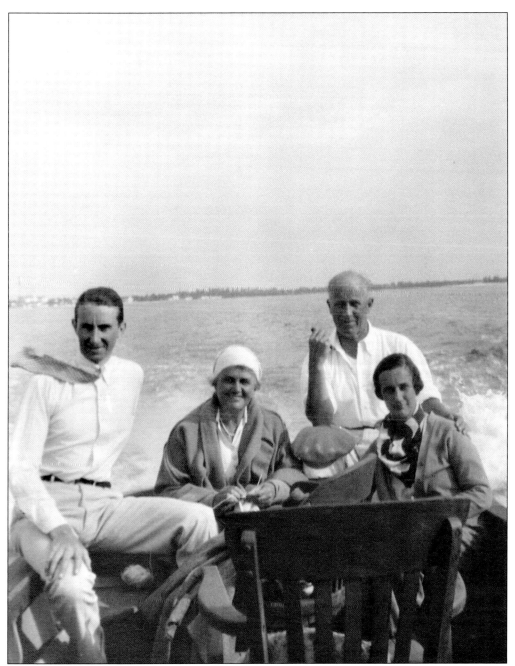

The owners of Mondongo Island during the 1930s were the Coggehall family. Kay DellaBitta, a Pine Island child at the time, recalled, "I remember the people on Mondongo would get all of us kids gifts and host a Christmas Party every year. They would spend at least two or three hundred dollars on us kids!" Here are, from left to right, the Pittmans and the Coggehalls, right as they cross Pine Island Sound near Mondongo Island. (BGHS.)

At 100 acres, Cabbage Key is best known for its Jimmy Buffett cheeseburger, Mary Roberts Rinehart's visits, and quirky George Washington wallpaper. The history of the island's tiny resort goes back to 1944, when Larry and Jan Stults purchased Cabbage Key with plans to open the island as a resort. The couple's three children helped run the resort through 1969, when it changed hands Larry Stults was known for his artistic flair, including giving art lessons to his guests and hosting weeklong art retreats. One of his paintings hangs in the Dollar Bill Bar. Here, in the 1950s, is the rest of the image featured on the book's cover—Jan is seen fanning Stults with a palm frond. (Wells family collection.)

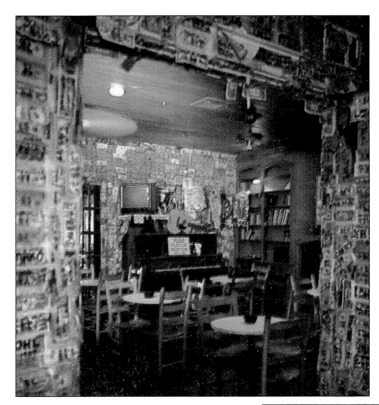

"Some mornings I walk in and the whole floor is covered with money," says Rob Wells, Cabbage Key Inn owner. "We just sweep it up and give it to charity." It is estimated about $65,000 in bills cover the walls and ceilings of the dining room and bar. Visitors to the island hardly glance at the sparse menu because they know what they want—a cheeseburger. Jimmy Buffett sang the praises of Cabbage Key with his hit "Cheeseburger in Paradise," said to have been inspired by and penned in the Dollar Bill Bar. (Wells family collection.)

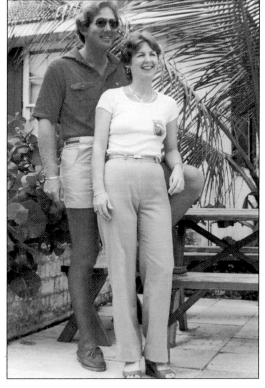

When Rob and Phyllis Wells purchased Cabbage Key in 1976, there was no electricity or phone service. Water was gathered in the water tower, which still stands on the island. "Everything comes in and out of here by boat," said Rob Wells Jr., the island's owner. The Wellses raised two sons, Robert III and Kenneth, on the island. Today Kenneth manages Cabbage Key, and Robert manages Pine Island's Tarpon Lodge, another family resort. (Wells family collection.)

Cabbage Key Inn manager Kenneth Wells stands with his brother Robert (left) and a tarpon during his childhood days on Cabbage Key. When asked about Hurricane Charley, he shared, "The eye of the storm went right over the island. Dad's comment was, 'Well, at least we are alive.' Mom rode out the storm huddled in the inn's pantry. They said it sounded like the inn was going through a car wash!" (Wells family collection.)

Mary Roberts Rinehart was a popular 1930s novelist and was credited with coining the phrase "The butler did it." She and her son purchased Cabbage Key, then called Palmetto Island, for $2,500 in 1929. In addition, they built a tarpon research laboratory on the island. The family left the island in 1934, and Rinehart became owner of a cottage on the north end of Useppa Island. Here is Rinehart's Cabbage Key cottage as seen in the 1950s. (Wells family collection.)

Under the 1862 Homestead Act, Frank M. Johnson was the first settler to homestead on Mound Key in 1891. Five years later, Frank Cushing visited Mound Key, by then referred to as Johnson's Key. Although not authenticated, a Spanish mission was reportedly located on Mound Key during the late 1600s, according to Rolfe Schell in *1000 Years on Mound Key*. Legend says they were starved out after the Calusa Indians surrounded the key, cutting off their supplies. Visitors to the island in 1931 are, from left to right, as follows: (first row) Calvin Uzzell, Marjorie Weinberg, Evelyn Uzzell, and A. T. Uzzell; (second row) Miss Weinberg and Randolph and Matt Uzzell Jr. (SWFMH.)

Said to be glimpsed by many but visited by few, Lofton's Island lies in the middle of the Caloosahatchee River between Fort Myers and North Fort Myers. At 9.3 acres, the island was created from dredged spoils from a river channel project beginning in 1910. J. L. Lofton, then in the dredging business, homesteaded the island in 1911. About growing up on the island until the mid-1930s, Lofton's daughter recalled, "We had a big ice box, so Daddy'd buy a 100-pound block of ice and bring it out on the bow of the boat. I attended school by rowing across the river." Here is Lofton's Island in the 1950s under the ownership of A. Lowell and Elino Hunt. (FMHM.)

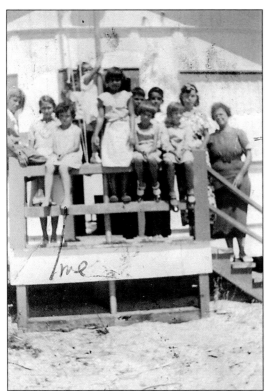

Beginning in the early 1900s, a school on Punta Blanca served the fisherfolk settlers. Taken during the 1934-1935 school year, teacher Mary Christian is shown with some of the last children to attend the one-room school, from left to right are the following: (first row) Guy Darna, Conrade Padilla, Ruby Coleman, Dick Darna, Pat Coleman, and Tiny Darna; (second row) Rufus Darna, Frances Levens, Raymond Rodriqus, and Earl Levens; (third row) Frances Barnes, Freddie Le Joiner, and Mrs. Christian. (Mary Nell Christian.)

Mary Christian's contract with the Fort Myers School Board was for $100 per month in 1934. Barron Collier provided the building, and on occasion, Mary Roberts Rinehart visited the island to read to the students. Christian's daughter, Mary Nell, recalled, "Each morning we began with a prayer, Bible reading and songs. In the one-room schoolhouse, I remember the American flag, bird charts, maps and paintings." (Mary Nell Christian.)

Schoolchildren rode the school boat captained by Joe Celec of Pineland. Here in the early 1960s, students, from left to right, Babe Darna, Dick Darna, Patsy Darna, Joe Celec, Taylor Stolts, and Christine Darna are preparing for the boat ride across Pine Island Sound. Taylor Stolts lived on Cabbage Key, while the Darna children lived on Cayo Costa. (Harry Celec.)

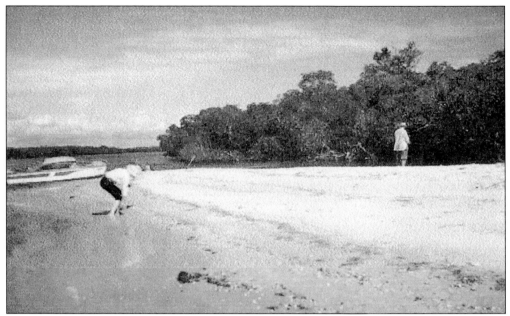

Black Island was named for the pirate Black Augustus. Leaving the rest of José Gaspar's crew around 1780, he took his share of the accumulated loot and built a hut on a strip of high ground at the southern end of Estero Island. John Butterfield, a Mound Key resident, claimed to have exchanged staples and supplies with the pirate until Augustus died in 1885. This postcard shows two visitors looking for shells on Black Island in the 1960s. (EIHS.)

Demere Key was once a Calusa Indian center of worship, based on the altars and walls recorded by explorer Frank Hamilton Cushing in 1895. Phil Degraff purchased Demere Key in 1954 and began building Sea Grape Lodge. The lodge was covered in a facade of whelk shells, many of which were collected for Degraff by Al Howard and his wife. Sold in 1972, the island's shell-lined terrace and shell-studded building are visible from Pine Island Sound. (MOTI.)

Born in 1928, Nellie Coleman lived in the Charlotte Harbor and Pine Island Sound area most of her life, fishing and repairing nets for a living. As an adult, she was a favorite of the children living on the various islands. In tune with nature, she knew the migration of the fish like few others. In an interview with Robert Edic in *Fisherfolk of Charlotte Harbor,* she said, "You can tell when a storm or something is comin' . . . those fish are [out of here]. There's nothing here." With the Stults children of Cabbage Kay, Nellie is seen here in her boat in the 1950s. (BGHS.)

"Sometimes you get a fish," Alfonso Darna said, "and sometimes you don't. That's why they call it fishing instead of catching." Arriving at the Punta Blanca fish house with a catch of mullet still within the net, Cayo Costa–born fisherman Alfonso Darna greets Joe DeWitt, known to most as "Chief." Darna's boat, *Skip Jack,* was laden with some 6,500 pounds of mullet caught in Captiva Pass in this photograph taken around 1938. (BGHS.)

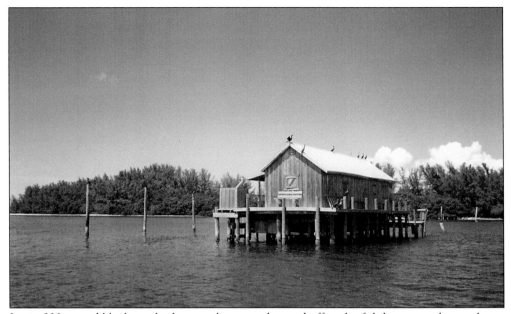

Ice in 300-pound blocks and other supplies were dropped off at the fish houses as the run boats picked up the waiting fish. In a conversation with Robert Edic in the 1990s, Esperanza Woodring said of the fish house run boats, "If we wanted groceries or shoes or anything, we would just write up an order and send it back on the run-boat. The next boat would bring it down. They would deduct it out of your pay. We got a little money." Shown here is a typical stilt fish house of the early 1900s. (BGHS.)

Fishing ranchos set up by Spanish-speaking fishermen, shown as dots on this map, were scattered on Lee County's islands from the 1800s through the early 1900s. The last inhabited rancho was located on Cayo Costa by the Toribio Padilla family, abandoned in 1905. José Caldez ran the oldest settlement on Useppa Island from 1784 to 1836. He returned to Cuba following a Seminole attack on Useppa Island. (Map by Merald Clark, from *Fisherfolk of Charlotte Harbor, Florida,* by R. F. Edic. Reprinted with permission, BGHS.)

BIBLIOGRAPHY

Anholt, Betty. *Sanibel's Story*. Virginia Beach: Donning Company Publishers, 1998.

Blanchard, Charles E., ed. *Boca Grande, Lives of an Island*. Boca Grande: Boca Grande Historical Society and Museum, 2006.

Board, Prudy Taylor, and Patricia Pope Bartlett. *Lee County: A Pictorial History*. Virginia Beach: Donning Company Publishers, 1985.

Captiva Library Board. *True Tales of Old Captiva*. Fort Myers: Sutherland Publishing, 1984.

Covington, James W. *The Story of Southwestern Florida*. Vol. I and II. New York: Lewis Historical Publishing Company, Inc., 1957.

Dimock, A. W., and Julian A. Dimock. *Florida Enchantments*. New York: The Outing Publishing Company, 1958.

Dormer, Elinore Mayer. *The Sea Shell Islands*. Tallahassee: Rose Printing Company, 1979.

Dunn, Bob, and Peter Goadby. *Saltwater Game Fishes of the World*. Portland, OR: Frank Amato Publications, 2000.

Edic, Robert F. *Fisherfolk of Charlotte Harbor, Florida*. Gainesville: University of Florida Press, 1996.

Fritz, Florence. The Unknown Story of World Famous Sanibel and Captiva. Parsons, WV: McClain Printing Company, 1974.

Hawkins, Betty. *Twice Upon a Time*. Fort Myers: Bollinger's Business Service, 1988.

Jordan, Elaine Blohm. *Pine Island, the Forgotten Island*. Chelsea, MI: Bookcrafters, Inc., 1982.

Marquardt, William H., and Darcie A. MacMahon. *The Calusa and Their Legacy*. Gainesville: University Press of Florida, 2004.

Oppel, Frank, and Tony Meisel, eds. *Tales of Old Florida*. Secaucus, NJ: Castle, 1987.

Schell, Rolfe. *1000 Years on Mound Key*. Fort Myers Beach: The Island Press, 1962.

White, Randy Wayne, and Carlene Fredericka Brennen. *Randy Wayne White's Gulf Coast Cookbook*. Guilford, CT: The Lyons Press, 2006.